the VISUAL BLUES

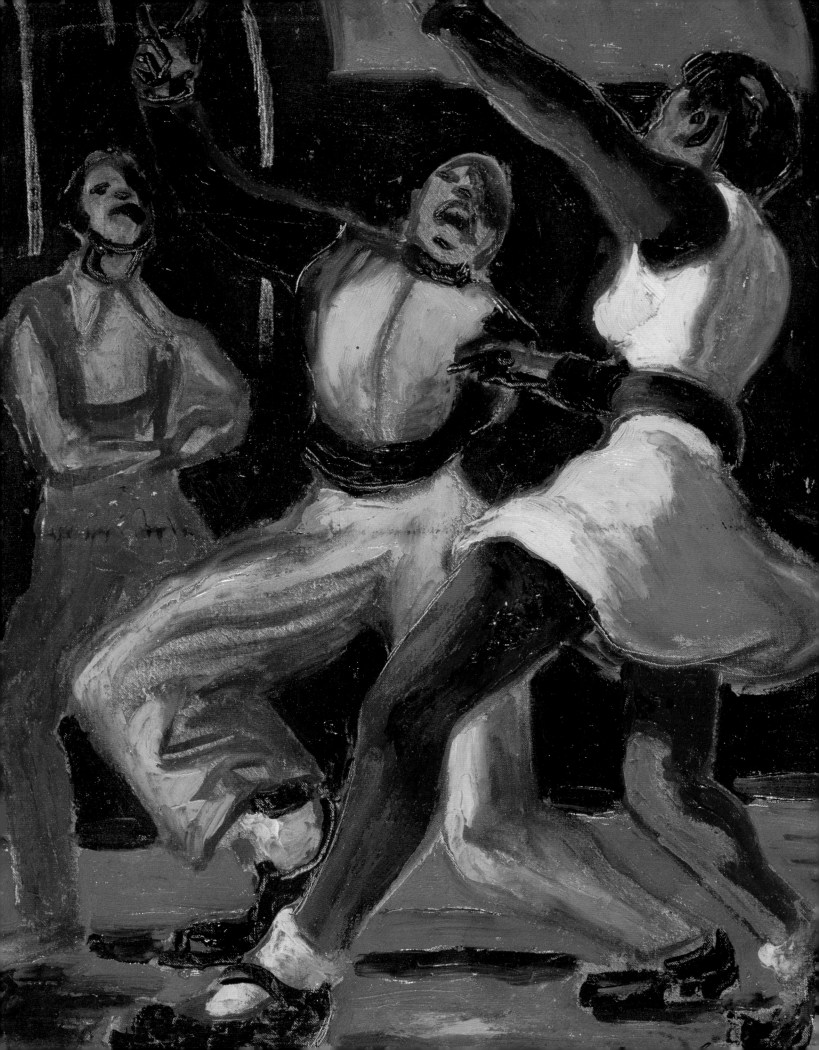

the VISUAL BLUES

edited by
Natalie A. Mault

essays by
R. A. Lawson
John Lowe
Natalie A. Mault
Margaret Rose Vendryes

with artist biographies by
Lauren Barnett and
Natalie A. Mault

LSU Museum of Art, Baton Rouge

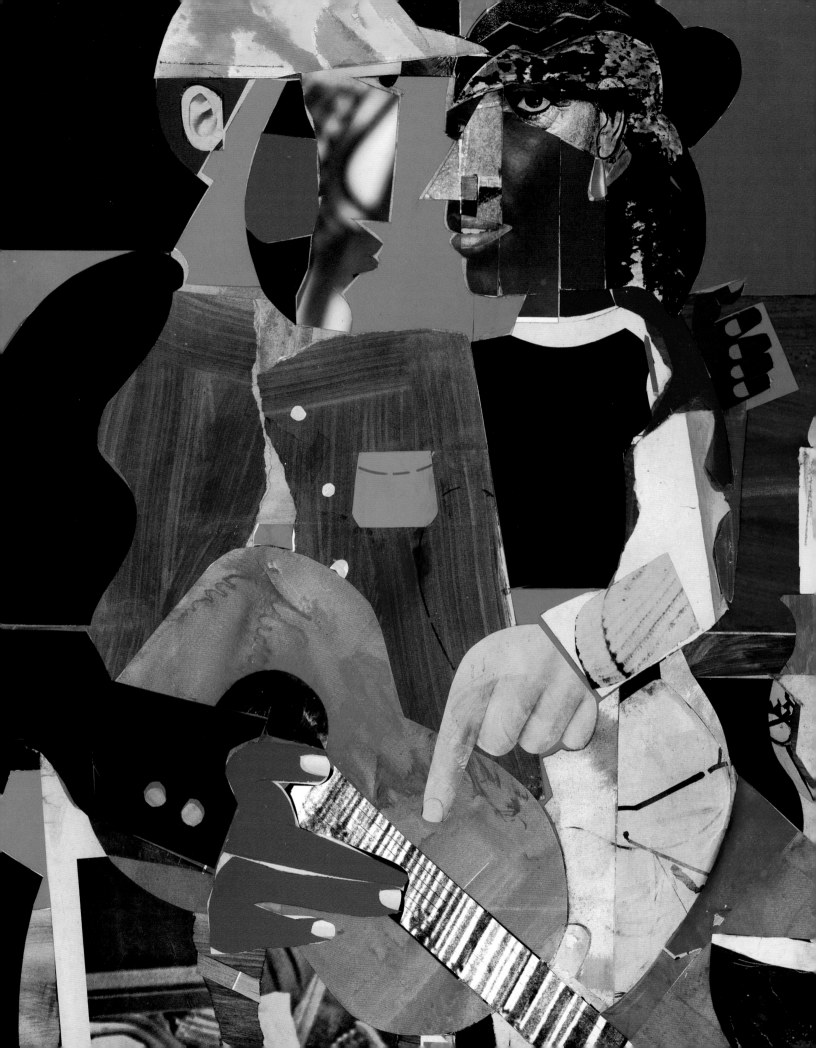

Contents

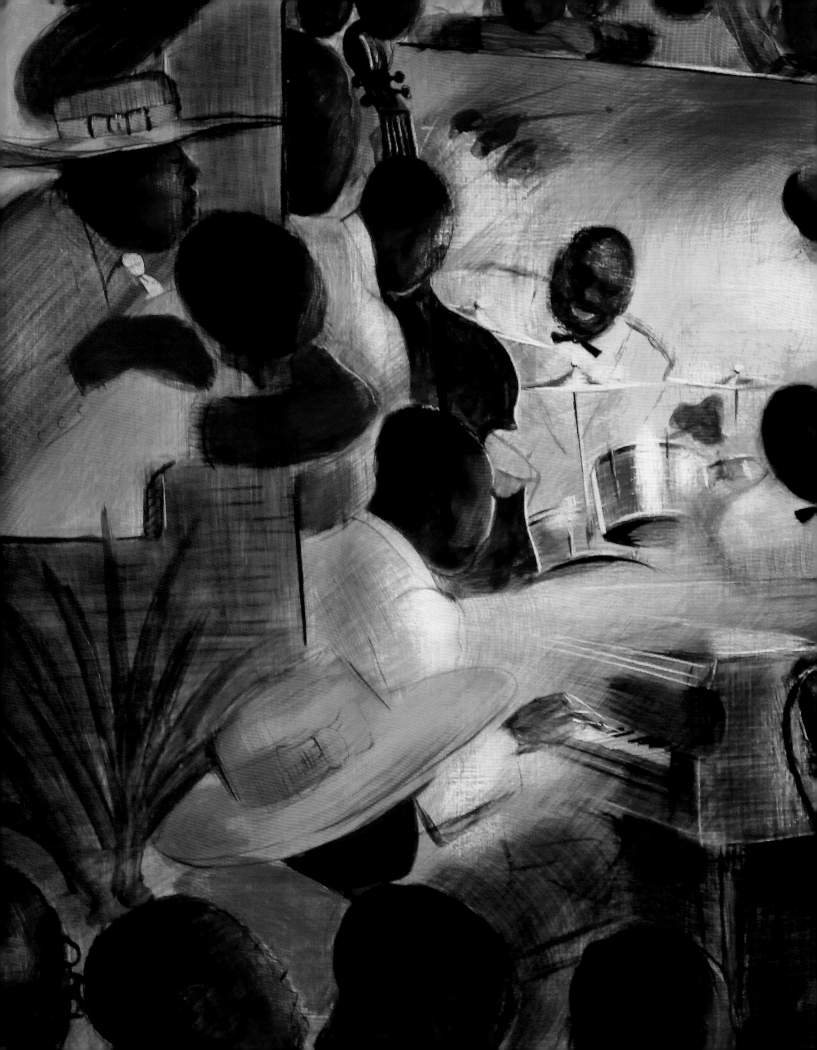

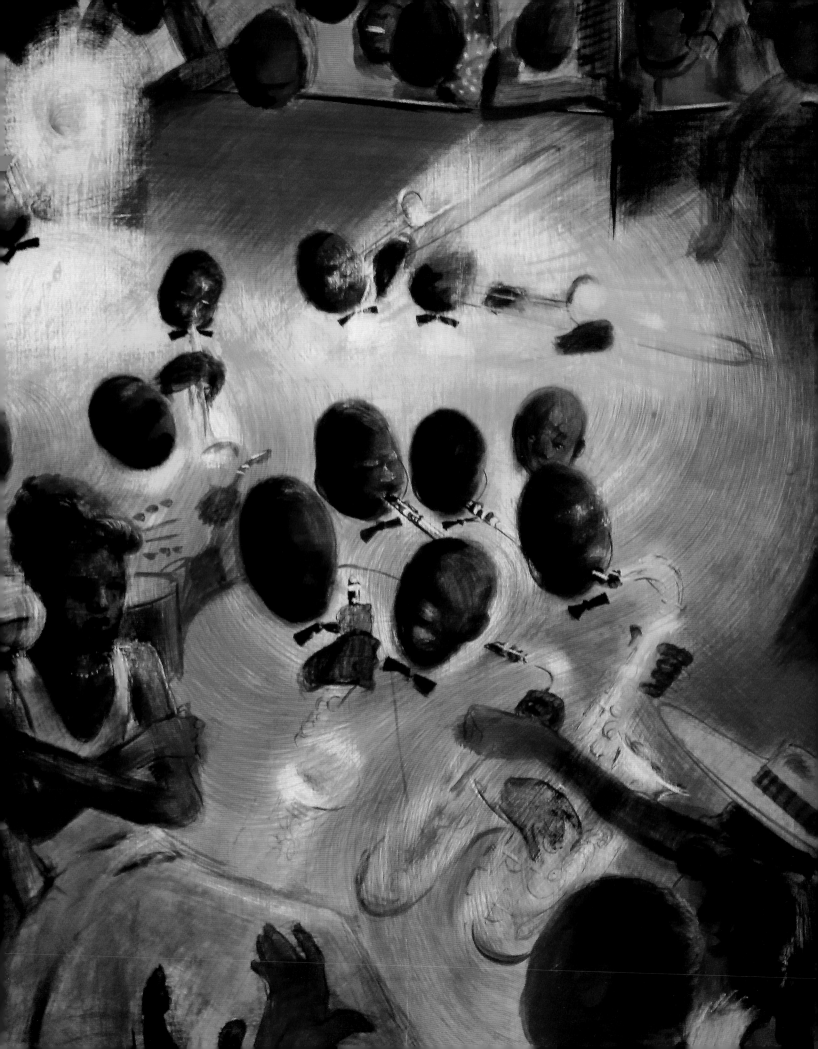

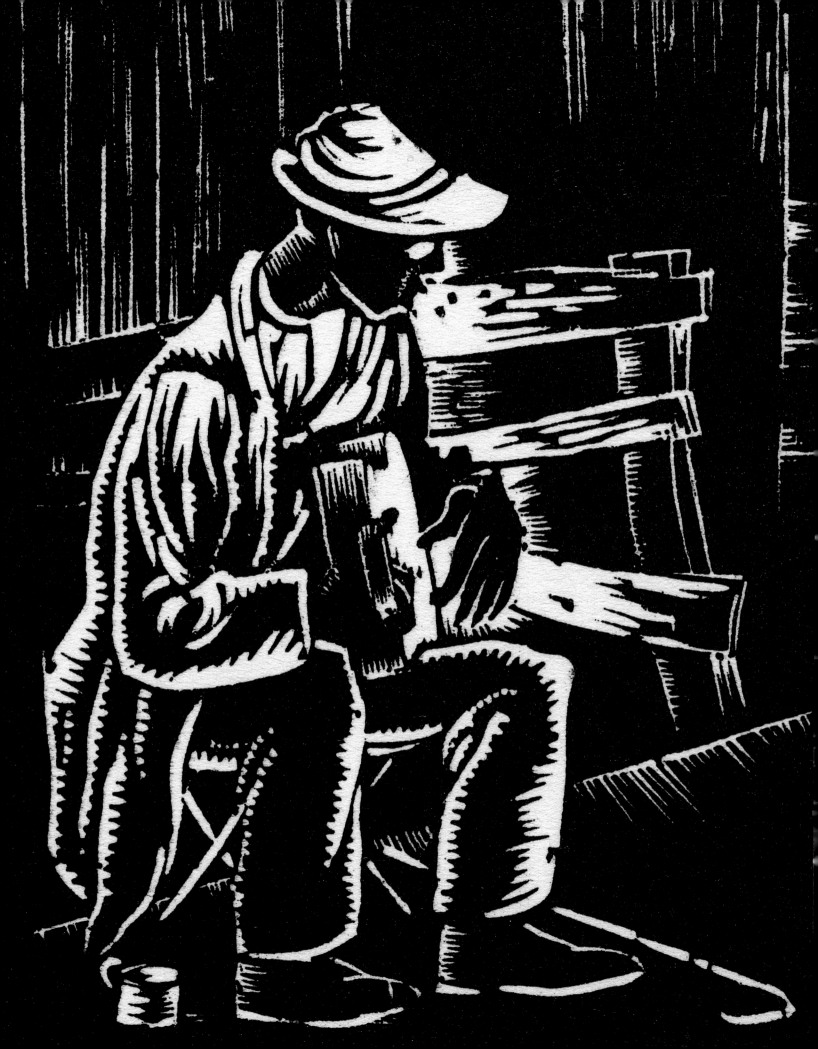

Foreword

The scholar Alain Locke coined the term "Harlem Renaissance" after editing his anthology *The New Negro* (1925). The term was eventually applied to a broad, interdisciplinary cultural movement that incorporated music, poetry, and visual art—a movement that took place in many major cities throughout the northern United States. In *The Visual Blues*, the Harlem Renaissance is interpreted from the perspective of its southern roots in blues and jazz music. The LSU Museum of Art, which is the art museum of Louisiana's flagship university, is the first institution in the region to mount an exhibition related to the Harlem Renaissance and the South. This exhibition and the accompanying catalogue offer a new view of the vibrant cultural exchange that took place at a pivotal moment in American history, one that demanded balancing tradition with assimilation as artists developed a new, music-inflected language. *The Visual Blues*, while fitting into a larger, statewide effort to present Louisiana's remarkable musical history, stands out as an exploration in a musical context of the contributions of visual artists.

The exhibition comprises fifty-eight paintings, drawings, prints, photographs, and sculptures. All but a few are by African American artists, some of whom have established reputations, such as Richmond Barthé, Aaron Douglas, and Loïs Mailou Jones, and others of whom are underrecognized and rarely exhibited publicly, such as Allan Rohan Crite and Jay Robinson. A wide range of artists were selected to illustrate the broad spectrum of work that found nourishment in the musical outpouring of the time; they include several white artists who documented the Harlem Renaissance or collaborated with African Americans. Viewed collectively, the artists featured in this groundbreaking exhibition represent the wellspring of unprecedented artistic creativity inspired by blues and jazz music.

9

A spotlight on the twenty-seven exceptional artists gathered here illumines five major themes that tie together the Harlem Renaissance: the Great Migration, Harlem represented, club and café culture, musical and visual structures, and the ongoing influence of the Harlem Renaissance. In the essay "Shake That Thang: Dancing Figures and Figures That Dance in African American Art," the independent curator and artist Margaret Rose Vendryes examines dance during the Harlem Renaissance, specifically the Lindy Hop and the jitterbug, as a natural response to blues and jazz. In "Blues, Jazz, and the Literature of the Harlem Renaissance," John Lowe, the Barbara Lester Methvin Distinguished Professor in the Department of English at the University of Georgia, explores the complex interplay between music and Harlem Renaissance literature in relation to the visual arts. R. A. Lawson, Associate Professor of History at Dean College in Franklin, Massachusetts, investigates the association between blues and jazz, and the migration of artists from the South to urban areas in the North, in his essay "Hearing the Blues in the Art of the Harlem Renaissance." And in "'Money, You've Got Lots of Friends': Patronage in the Harlem Renaissance," Natalie A. Mault, Curator at the LSU Museum of Art, surveys opportunities for artists during the Harlem Renaissance and the relationships between African American artists and their patrons. The biographies of the featured artists concentrate on the artists' lives and careers during the Harlem Renaissance and are not intended to be comprehensive.

It takes many individuals and organizations to produce an exhibition of this caliber. Foremost in our thanks is the Art Dealers Association of America, whose award to support original research by members of the Association of Art Museum Curators provided critical funding for the development phase of *The Visual Blues*. The ADAA enabled Ms. Mault to conduct research at archives and museums, many of which in turn generously lent works of art to the exhibition. These lenders include the Amistad Research Center, Tulane University, New Orleans; Bowdoin College Museum of Art, Brunswick; the Brooklyn Museum; the California African American Museum, Los Angeles; the Center for Creative Photography, University of Arizona, Tucson; A Gallery for Fine Photography, New Orleans; the Georgia Museum of Art, University of Georgia, Athens; the Gibbes Museum of Art, Charleston; the Harvey B. Gantt Center for African-American Arts + Culture, Charlotte; the Howard University Gallery of Art, Washington, DC; the Madison Museum of Contemporary Art; the Mary and Leigh Block Museum of Art, Northwestern University, Evanston; the Metropolitan Museum of Art, New York; the Museum of Fine Arts, Houston; the National Portrait Gallery, Smithsonian Institution, Washington, DC; Jumaane N'Namdi; the Philadelphia Museum of Art; the Saint Louis

Art Museum; the SCAD Museum of Art, Savannah; Jason Schoen; the Smithsonian American Art Museum, Washington, DC; the Spencer Museum of Art, University of Kansas, Lawrence; the Stella Jones Gallery, New Orleans; the Thelma Harris Gallery, Oakland; and the University Art Gallery, Western Illinois University, Macomb.

For the development of this important exhibition and catalogue, special acknowledgment is given to LSU Museum of Art Curator Natalie A. Mault, who has worked tirelessly on the exhibition's organization, ably assisted throughout the project by former curatorial intern Lauren Barnett. We also extend special thanks to Kristin Malia Krolak, Gallery Director at the Alfred C. Glassell Jr. Gallery. Her passion for promoting Baton Rouge's blues history and a discussion with Ms. Mault sparked the idea for this exhibition. It is our good fortune to have worked closely with some of the foremost specialists on the Harlem Renaissance. We are grateful to R. A. Lawson, John Lowe, and Margaret Rose Vendryes for their contributions to the catalogue. For their support and assistance with research, we particularly acknowledge Marisa Bourgoin, Richard Manoogian Chief of Reference Services at the Archives of American Art at the Smithsonian Institution, Washington, DC; Christopher Harter, Director of Library and Reference Services at the Amistad Research Center at Tulane University; Andrew Salinas, Reference Archivist at the Amistad Research Center; and Chelsea Weathers, Research Associate at the Harry Ransom Center at the University of Texas at Austin. For the publication, we are grateful to Marquand Books, where we relied on the guidance of Ed Marquand, Adrian Lucia, Ryan Polich, Jeff Wincapaw, and Melissa Duffes. Finally, we would like to thank our touring partner at the Telfair Museums, Savannah.

The culture of the Harlem Renaissance fostered friendships and collaborations among artists of many disciplines. A wide circle of performers, poets, playwrights, and painters socialized and lent support to one another. Jazz infused popular music, entered literature and poetry, and shaped the imagery in visual art. *The Visual Blues* reminds us that permeable boundaries among the arts give rise to the best of artistic creation.

Dr. Jordana Pomeroy
Executive Director
LSU Museum of Art

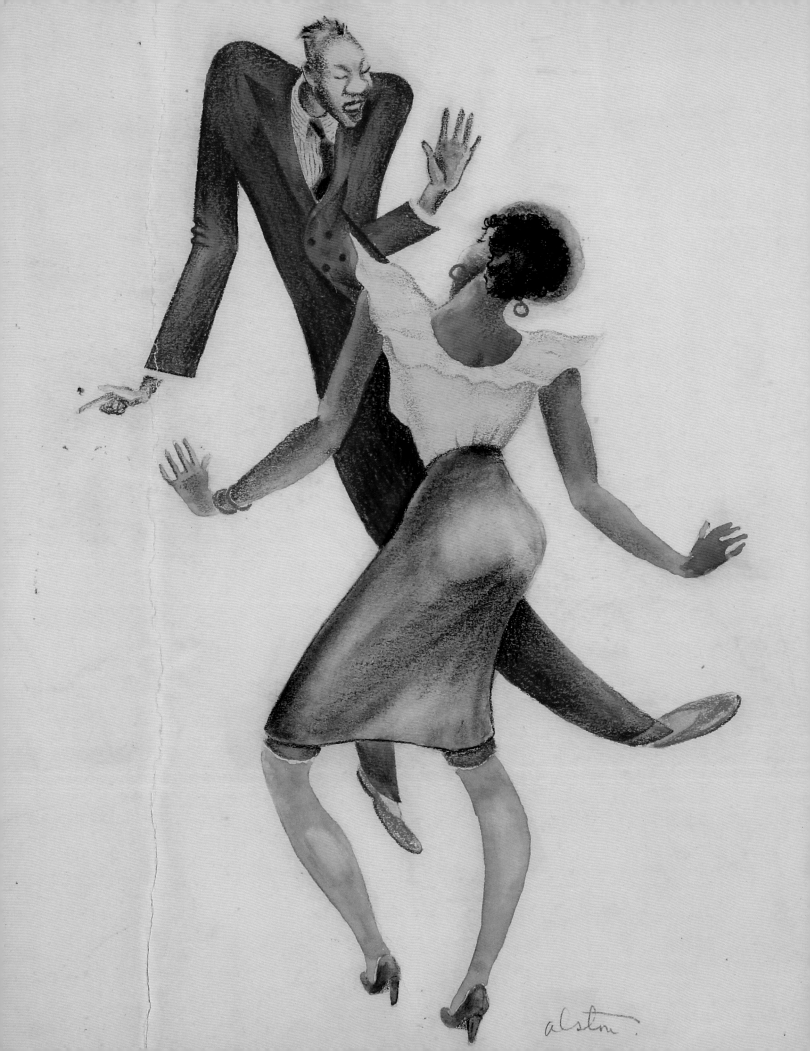

Shake That Thang
Dancing Figures and Figures That Dance in African American Art

Margaret Rose Vendryes

More than a dozen of the artists represented in *The Visual Blues* exhibition directly reference dance. Their work regards, reveals, and revels in black bodies infused with music that we cannot hear but that we can sense by following lines, reacting to color, and reading forms.

It might appear curious that this exhibition refers to the blues when it was jazz riffs that prevailed during the Harlem Renaissance. But if we recall the insistence of W. C. Handy, the "father of the blues," that everything that is authentic about jazz stems from the blues, *The Visual Blues* is indeed an appropriate title. Visualizing the blues broadened and deepened during the years under scrutiny here—the pre–World War II era of mass migration, when African Americans left the rural South for a better life in urban centers such as Chicago, Detroit, and New York City.

It is no surprise that blues-idiom music,[1] personal and yet communal, inspired a variety of artists to make its rhythms accessible to our eyes. Dance is temporal. And as such, dance is also ephemeral. Corporal movements, here and then gone, become nostalgia even before the tune has ended. Such fleeting moments are difficult to capture, yet artists of the Harlem Renaissance succeeded in conveying the sight, the feel, and the sound of dancers and the music that stirred them.

In 1925, the journalist J. A. Rogers referred to jazz as "a tonic for the strong and a poison for the weak" in his article for the groundbreaking special issue of *Survey Graphic* devoted to Harlem.[2] Rogers's essay was illustrated by Winold Reiss, a German transplant whose African-inspired designs and stylized portraits of African Americans and Native Americans often appeared in race publications (publications intended primarily for an

Opposite: Charles Alston (1907–1977), *Lindy Hop at the Savoy* (detail), ca. late 1930s. Watercolor. Thelma Harris Gallery, Oakland, CA.

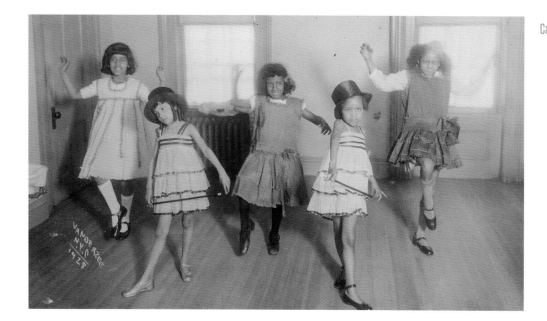

Cat.1 James Van Der Zee (1886–1983), *Dance Class*, 1928. Gelatin silver print, 8¹/₁₆ × 10 in. (20.5 × 25.4 cm). Spencer Museum of Art, University of Kansas, Lawrence, Museum purchase: Peter T. Bohan Art Acquisition Fund.

African American audience, that is). Reiss was a mentor to Aaron Douglas, and his influence can be discerned in Douglas's *Play de Blues* (cat. 13), which was published in 1926 by the journal *Opportunity* as an illustration for Langston Hughes's poem "Misery."[3]

Using the Art Deco style favored during the 1920s (and by Reiss), Douglas depicts a piano player and songstress laying into blues lyrics. The silhouetted figures are a brilliant visual translation of Hughes's words below: "A good woman's cryin'/ for a no-good man." Hughes often wrote of love and the blues in tandem, for, as his biographer Arnold Rampersad puts it, "the blues drifts in most often on the heels of lost love."[4] Douglas's fiery musician causes rays of energy to rise from his piano (in what was a signature flourish in Douglas's work in this period) and meet the singer's upraised hand. The eroticism of the image is blatant. Similar rays emanate from the African sun above a line of undulating women in *Sahdji (Tribal Women)* of 1925 (cat. 23). Douglas skillfully arranges solids and voids in a visual cadence that simulates percussion instruments: *drone, tremble, thunder, gong, trill,* and *slur* are among the many "sounds" that Douglas and other artists represented in this exhibition wanted us to hear.

It is difficult to remain motionless when music fills the air. That music might be straightforward and formal, as we surmise it was for the five little performers James Van Der Zee photographed in 1928 diligently tapping and sliding across a Harlem dance studio's polished wood floor (cat. 1). Or the music might be unrehearsed, similar to the strains of the rustling, freshly ironed Sunday frocks of the women tittering on their way from church in Hale Woodruff's *Sunday Promenade* (ca. 1935; cat. 4). While teaching at Atlanta

University, Woodruff created a suite of small-format linocuts that depicted the life around him (cats. 12, 15, 16, 19, 56). His black-and-white compositions juxtapose the geometry of built architecture with the organic flow of bodies in motion; in style and subject matter, they are a visual, rather than a musical, score for a Deep South blues tune.

During the Harlem Renaissance, blues singers were the "poets laureate" of African America.[5] Successful singers such as Bessie Smith lived the blues and in performance enacted the words they sang through their gesturing bodies. Times had changed since an association with the blues signified a woman of loose morals. Dancers in African American clubs were quintessential interpreters of music, which they allowed to transport them beyond the cabarets' four walls. The New York Photo League photographer Aaron Siskind amassed thousands of images of 1930s Harlem in an effort to document the successes and the failures of the New Deal in this precinct of New York City (cats. 26, 51). Like Woodruff, Siskind managed to reveal the good with the bad—the ability to enjoy time on the town combined with sequestered lives in tenements and slums. For a working-class African American, the place to gather and listen to music was often little more than a tiny neighborhood apartment-turned-juke-joint where the latest tunes from a Victrola filled the room, as in Charles Sallee's *Swingtime* (1937; cat. 50). That the quarters were close, and the booze cheap, didn't seem to matter. Many African Americans went to lift their spirits with good music and the chance to dance.

The freedom to "cut a rug" across an open expanse of hardwood floor was available to Harlemites at the Savoy Ballroom well into the 1950s.[6] A popular entertainment

Cat. 2 Carl Van Vechten (1880–1964), *Cab Calloway*, 1933. Gelatin silver print, 5⅜ × 3⁷⁄₁₆ in. (13.7 × 8.7 cm). National Portrait Gallery, Smithsonian Institution, Washington, DC.

Cat. 3 Ellis Wilson (1899–1977), *Shore Leave*, 1943. Oil on Masonite, 16 × 20 in. (40.6 × 50.8 cm). Amistad Research Center, Tulane University, New Orleans.

Hale Woodruff (1900–1980), *Sunday Promenade*, ca. 1935, printed 1996. From the portfolio *Selections from the Atlanta Period*. Linocut, sheet: 19 × 15 in. (48.3 × 38.1 cm), image: 9¾ × 7¾ in. (24.8 × 19.7 cm). Gibbes Museum of Art, Charleston, SC, Gift of Reba and Dave Williams.

Cat. 5 Romare Bearden (1911–1988), *Jazz II*, 1980. Screenprint, sheet: 31 × 41½ in. (78.7 × 105.4 cm), image: 26⅞ × 37¹¹/₁₆ in. (68.3 × 95.8 cm). Stella Jones Gallery, New Orleans.

venue, the Savoy was usually packed with youthful bodies perfecting popular dances and inventing new ones. Charles Alston's *Lindy Hop at the Savoy* (ca. late 1930s; detail, p. 12) isolates a couple from the crowded dance floor. They are frozen like clef notes on a blank page; they float as if dancing on a cloud. Their music is as smooth and harmonious as the lines that blend their forms into one.

Ellis Wilson's painting *Shore Leave* (1943; cat. 3), conversely, is jammed with lean dancing machines. A Kentucky native, Wilson spent almost a decade in Chicago, where he studied at the School of the Art Institute of Chicago before settling in Manhattan in 1928. His travels throughout the South in the early 1940s were spurred by a determination to reconnect with black "folk" and make a name for himself as a chronicler of his time.[7] In *Shore Leave*, we witness an evening of fun during a time in American military history when segregation was standard. The rakish slant of the sailors' hats and the long reach of their bell-bottoms-clad legs rap out a staccato beat across the horizontal expanse of Masonite under twinkling strings of lights.

In the years after the United States entered the Second World War, swing dances such as the Lindy Hop and the jitterbug were transformed into impressive gymnastic feats, and then into competitive performances.[8] Couples dressed to impress in coordinated costumes—like the duo in Claude Clark's *Jam Session* (1943; cat. 34)—and drew such large audiences to dance clubs that spectators often outnumbered dancers. Several works of art, among them Palmer Hayden's *Bal Jeunesse* (1926; private collection, New York) and Archibald J. Motley Jr.'s *Nightlife* (1943; Art Institute of Chicago), document the rambunctious spectacle of agile and athletic swing-era dancers.[9]

The painter William Henry Johnson, after many years abroad, landed back in New York, in 1938, with an interest in black popular culture that included a fascination with folk art.[10] For many artists, black and white, Harlem was an epicenter of avant-garde music that, according to the cultural critic Paul Gilroy, fed their "enthusiasm for the exotic and the instinctive."[11] With what has been called a faux-naïve style,[12] Johnson, who had limited resources, composed inexpensive woodblocks and screen prints in which vibrantly colored cutout forms are arranged and layered; the works appear rough but are in fact sophisticated—much like blues-idiom music. One such screen print is *Jitterbugs II* (1942; cat. 6). Johnson's body of work reveals to us a visionary artist. His method and style sum up a post–Harlem Renaissance era in America when resourcefulness, determination, and inventiveness resulted in art that remained sensitive and sensual—a visual swing of its time—and that continued to reflect the good times in the midst of war and heightened racial discrimination.

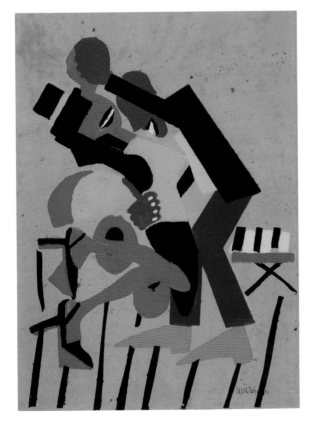

Cat. 6 William Henry Johnson (1901–1970), *Jitterbugs II*, 1942. Screenprint, sheet/image: 14 × 11 in. (35.6 × 27.9 cm). Amistad Research Center, Tulane University, New Orleans.

J. A. Rogers had put it best when he wrote in 1925: "Those who laugh and dance and sing are better off even in their vices than those who do not."[13] The blues were never just about being blue.

A few of the artists included in *The Visual Blues* exhibition were inspired by dance performed on a stage for an attentive, seated audience, and their works are invigorated by the modern music composed for more formal, theatrical dance. The whimsical imps dancing in leotards across dinner plates designed by Richard Bruce Nugent in the 1950s (cat. 45) burst out of their frames in studied gestures that are no less exuberant than those of Alston's dancers in *Lindy Hop at the Savoy*. The sound we imagine here is softer and perhaps more melodic than the music accompanying the gyrating dancers we have met so far. This kind of orchestral modern-dance music would also have been in the ear of Harald Kreutzberg, the German dancer whose portrait head Richmond Barthé modeled in 1937 (cat. 22). Barthé studied dance with members of the Martha Graham troupe to help him capture the body in dramatic movement in his art. His depictions of dancers in private rapture are some of his most dynamic sculptures. We see only the dancer's head, but the slight bow, the closed eyes, and the relaxed jaw evoke a man immersed in music.

Rocking, swaying, and nodding to a tune, accompanied by lyrics that tell a tale of loss and regret—this is what most of us would describe as experiencing the blues. However, blues-idiom music can also lift you to your feet; it can

create what Rogers called a "tremendous spirit of go."[14] There is a kind of blues that enters the body only to escape in dance. Faith Ringgold brought that "spirit of go" to her 1986 screen print *Groovin High* (cat. 48). The dance floor is full of bodies, yet the couples have enough space to show off their creativity. Ringgold arranged her figures to form a crazy quilt of patterned dresses, bright jackets, fashionable hats, and coiffured curls that recalls the importance of clubs and dance halls to African American self-expression.[15] These were valuable communal spaces where you could safely let your guard down.

Blues and jazz musicians can make their instruments do new and unexpected things that invigorate their sound. The African American artists we encounter in the present exhibition, working within traditional modes of drawing, painting, and sculpture, similarly invigorated their work— by visualizing the blues.

NOTES

1. The term "blues idiom" is used by Robert G. O'Meally in his discussion of writings by Ralph Ellison and Albert Murray about the affinity with jazz of their friend Romare Bearden's art. Robert G. O'Meally, "'We Used to Say "Stashed"': Romare Bearden Paints the Blues," in *The Hearing Eye: Jazz and Blues Influences in African American Visual Art*, ed. Graham Lock and David Murray (New York: Oxford University Press, 2009), 175. For the role in

Cat. 7 Romare Bearden (1911–1988), *Louisiana Serenade*, 1979. Lithograph, sheet/image: 24½ × 33⅞ in. (62.2 × 86 cm). Smithsonian American Art Museum, Washington, DC., Gift of Eugene I. Schuster.

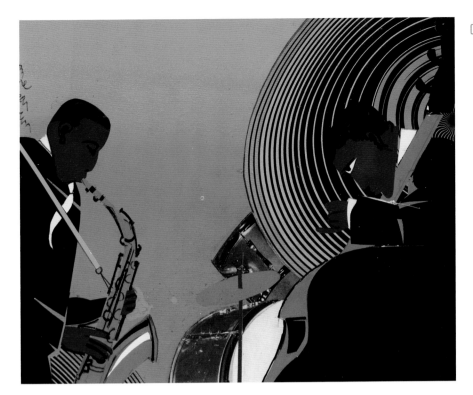

the Harlem Renaissance of black musical aesthetics developed in the Jim Crow South, see R. A. Lawson's essay in this volume.

2. J. A. Rogers, "Jazz at Home," in "Harlem: Mecca of the New Negro," ed. Alain Locke, special issue, *Survey Graphic* 6, no. 6 (March 1925): 667. An expanded version of this issue of *Survey Graphic* was published, also in 1925, as *The New Negro*. For the anthology's contents, see John Lowe's essay in this volume.

3. The 1926 *"Opportunity" Art Folio* is a portfolio of six poems by Hughes, each illustrated by Douglas. All the poems are letterpress; one illustration is a halftone reproduction, and all the others are relief prints.

4. Arnold Rampersad, *The Life of Langston Hughes,* vol. 1, *1902–1941: I, Too, Sing America* (New York: Oxford University Press, 1986), 142.

5. Carole Marks and Diana Edkins, *The Power of Pride: Stylemakers and Rulebreakers of the Harlem Renaissance* (New York: Crown Publishers, 1999), 122.

6. Information about the Savoy Ballroom from Ken Burns's documentary film *Jazz*, including audio excerpts, is available online: "Savoy Ballroom: Where Harlem Dancers Invented the Lindy Hop," PBS, accessed January 13, 2013, http://www.pbs.org/jazz /places/spaces_savoy_ballroom.htm.

7. For the most comprehensive biographical information, see Albert Sperath et al., *The Art of Ellis Wilson*, exh. cat. (Lexington: University Press of Kentucky, 2000).

8. See Ivan I. Sanderson, "The History of Jazz Dances," in *Anthology of American Jazz Dance*, ed. Gus Giordano (Evanston, IL: Orion Publishing House, 1975).

9. Hayden's *Bal Jeunesse* is reproduced in David C. Driskell, *Harlem Renaissance: Art of Black America* (New York: Abrams 1987), pl. 11; for Motley's *Nightlife*, see the Art Institute of Chicago website, http://www.artic.edu/aic/collections/exhibitions /AfricanAmercian/Nightlife.

10. The most authoritative account of Johnson's career remains Richard J. Powell, *Homecoming: The Art and Life of William H. Johnson* (Washington, DC: National Museum of American Art, Smithsonian Institution; New York: Rizzoli, 1991).

11. Paul Gilroy, "Modern Tones," in David A. Bailey et al., *Rhapsodies in Black: Art of the Harlem Renaissance*, exh. cat. (London: Hayward Gallery; London: Institute of International Visual Arts; Berkeley: University of California Press, 1997), 104.

12. Johnson's use of a folk-aesthetic "naïveté" is treated by Powell, *Homecoming,* 138.

13. Rogers, "Jazz at Home," 712.

14. Ibid., 666.

15. Shane White and Graham White, "Strolling, Jooking, and Fixy Clothes," in *Stylin': African American Expressive Culture from Its Beginnings to the Zoot Suit* (Ithaca, NY: Cornell University Press, 1998), 153–79.

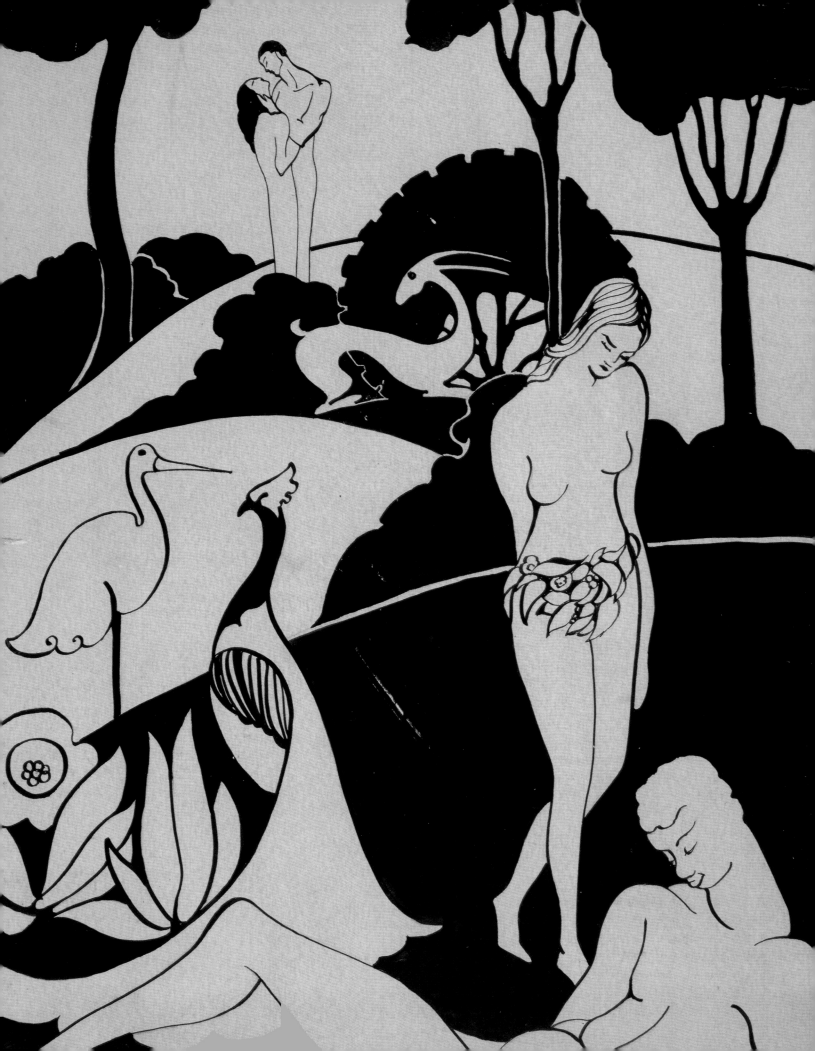

Blues, Jazz, and the Literature of the Harlem Renaissance

John Lowe

Harlem was a magnet for both black and white Americans during the turbulent 1920s, when it was commonly referred to as the "black metropolis"—a city within a city. An emerging artistic community in Harlem became the wellspring of a black literary renaissance, as thousands of African Americans, many from the South[1] and the Caribbean, migrated to New York and other northern cities. What made Harlem special was the complex interplay of music, dance, art, and literature. Many of the essays, plays, poems, stories, and novels that were generated "up in Harlem" profited from the creative ferment, as writers represented the spectrum of black life: "down-home" cultures, urban landscapes, the jazz-infused club scene, and "downtown" black artists who were making inroads in mostly white Broadway theater.

The Harlem Renaissance is widely regarded as the first appearance of black modernism on the international stage. A major effort was made to revive the arts and traditions of Africa, which were already revolutionizing European aesthetics through the work of artists such as Picasso, Braque, Matisse, Arp, and Brancusi and composers such as Darius Milhaud, whose 1922 visit to Harlem was reflected in his jazz-inspired ballet *The Creation of the World* (1923).[2] In the wake of Freud's writings, earlier in the century, about primitive society and primitive instinct, and after the late nineteenth-century colonization of Africa had made African sculpture known in the West, European avant-garde artists sought revitalization through the art forms of "primitive" peoples, who were thought to have preserved a vitality that had been drained from Western society. While the so-called primitivist vogue was in many ways condescending, numerous African American artists embraced the "primitive" label. They incorporated African rhythms in ragtime, then

Opposite: Gwendolyn Bennett (1902–1981), *Adam & Eve* (detail of cat. 33), 1932. Amistad Research Center, Tulane University, New Orleans.

in the blues, and, finally, in jazz and in language—in the dances of Josephine Baker, for example, and in the angular art of William Henry Johnson (1942; cat. 6) and the celebrated poem "Heritage" (1925), by Countee Cullen, in which the poet asks, *What is Africa to me?*"

The literature of the Harlem Renaissance had its origins in oral folk culture,[3] whose transmission was enabled by repetition, and many African American sermons, songs, and, ultimately, verse were strongly shaped by the repetitive, rhythmic music of Africa. Successful sermons repeat the main points several times, so that the auditors will get the lesson and take it away with them. The blues form is based on repetition, as in the song "That Ain't Right" (1942):

> Baby, baby, what is the matter with you?
> Baby, baby, what is the matter with you?
> You've got the world in a jug, and you don't have
> a thing to do.[4]

At the same time, performers frequently varied lyrics, improvising as they constructed "the changing same."[5] Repetition and improvisation became central components of jazz.

One might say that the Harlem Renaissance began in musical performance, with ragtime and the cakewalk. The poet Langston Hughes credited the musical *Shuffle Along,* which opened on Broadway on May 23, 1921, with giving "just the proper push" to the African American cultural renaissance.[6] The musical's composers, Noble Sissle and Eubie Blake, contributed a memorable score, including the hits "Love Will Find a Way" and "I'm Just Wild about Harry." Critics (both white and black) celebrated

the exuberant dancing, which engendered several crazes in Harlem clubs. The ever-changing cast included Florence Mills, Josephine Baker, Paul Robeson, and Mae Barnes.

Blacks began to appear in solo concerts around 1923, when the tenor Roland Hayes performed at Town Hall (spirituals were included in his repertoire). In 1927, Duke Ellington began playing at the Cotton Club, which attracted whites eager to hear the new black music. The first exhibition of work by African American artists took place the following year, under the patronage of the Harmon Foundation,[7] and featured the work of Hale Woodruff, Aaron Douglas, and many others who had close ties with writers.

The great precursor of the Harlem novel was James Weldon Johnson's *Autobiography of an Ex-Colored Man* (1912), a tale about a black man who passes for white; it pays close attention to the ragtime craze, which propels the musician-narrator on a tour of Europe. Ragtime's syncopated rhythms had a profound effect on the experimental prose of the Harlem Renaissance, particularly Jean Toomer's novel *Cane* (1923), which introduced a modernist element into African American literary discourse. The intersection of literature and music reached an apogee in the now classic collection *The New Negro* (1925). Edited by Alain Locke, a Rhodes scholar who taught at Howard University, in Washington, DC, the volume features poems, plays, essays, and short stories, as well as illustrations by leading new artists. It is also full of reflections on the role music plays in an uprooted, scattered culture. The dedication page—Locke addressed the book "to the younger generation"—includes a staff of music and the words "O, rise, shine for Thy Light is a' com-ing"; this quotation from a spiritual signals the

Cat. 9 Carl Van Vechten (1880–1964), *Langston Hughes*, 1939, printed 1983. Photogravure, framed: 16 × 24 in. (14.1 × 21.4 cm). National Portrait Gallery, Smithsonian Institution, Washington, DC, Gift of Prentiss Taylor.

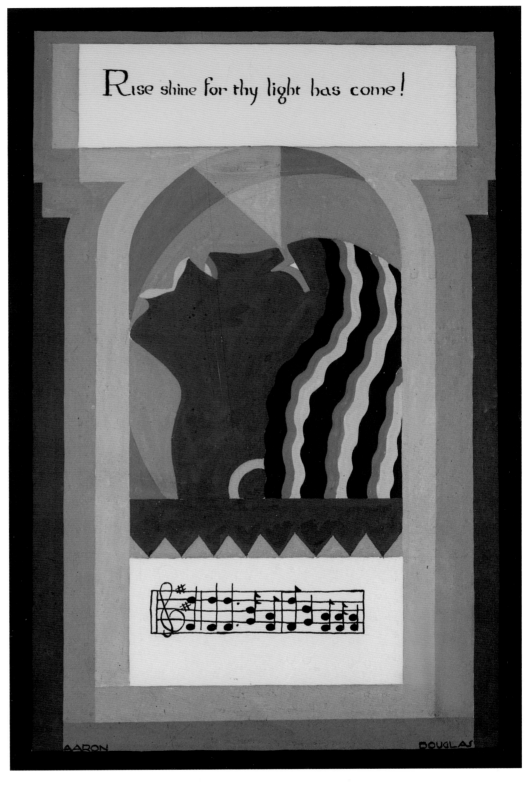

Cat. 10 Aaron Douglas (1899–1979), *Rise, Shine for Thy Light Has Come*, 1924. Ink and tempera on paper, 11⅓ × 8¼ in. (28.8 × 21 cm). Howard University Gallery of Art, Washington, DC.

Cat. 11 Prentice Herman Polk (1898–1984), *Noble Sissle*, 1937. Gelatin silver print, 10 × 8 in. (25.4 × 20.3 cm). California African American Museum, Los Angeles, Gift of P. H. Polk.

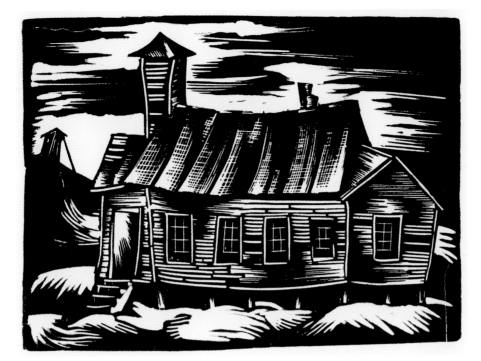

Cat. 12 Hale Woodruff (1900–1980), *Old Church*, 1935, reprinted 1996. From the portfolio *Selections from the Atlanta Period*. Linocut, sheet: 15 × 19 in. (38.1 × 48.3 cm), image: 6½ × 9 in. (16.5 × 22.9 cm). Gibbes Museum of Art, Charleston, SC, Gift of Reba and Dave William.

musical roots of the era. (The same musical bar and quotation appear in Aaron Douglas's *Rise, Shine for Thy Light Has Come* [1924; cat. 10], which Locke would later acquire.) A section of the anthology devoted to music featured an essay by Locke on spirituals; the expressionistic poem "Negro Dancers," by Claude McKay; "Jazz at Home," an essay by J. A. Rogers; "Song," a poem by Gwendolyn Bennett (who was also an artist); and two of Langston Hughes's greatest poems, "Jazzonia" and "Nude Young Dancer." Many of the superb illustrations—Aaron Douglas's *Music* and *Roll, Jordan, Roll*, above all—were inspired by music.

Another key volume, *Ebony and Topaz: A Collecteana* (1927), edited by Charles S. Johnson, similarly contains a variety of literary works, many of them influenced by musical forms; it also features suggestive and stylized illustrations by Charles Cullen (who designed the jacket), Richard Bruce Nugent, and Aaron Douglas. More provocative than *The New Negro*, the volume followed the precedent established by the notorious one-issue literary magazine *Fire!!*, which had been started by Nugent, Zora Neale Hurston, Hughes, and others in 1926, in an effort to shatter what they saw as the excessive propriety of *The New Negro* (which had its origins in a special issue of the journal *Group Survey*). It, too, features daring illustrations by Nugent and Douglas.

If there is one image that can stand for the whirling energies of the Harlem Renaissance, it is the figure of the dancing woman.[8] Over and over she appears in stories, poems, and artworks of the period (cats. 13, 55), encompassing the dynamism and creativity of the moment. Arna Bontemps, speaking of his days as a young poet in Harlem during the twenties, reported that "up and down the streets of Harlem untamed youngsters were doing a wild dance called the Charleston. They were flitting over the sidewalks like mad while their companions, squatting nearby, beat out tom-tom rhythms on kitchenware."[9]

No writer was more dazzled by the blues, dance, and jazz than Bontemps's close friend Langston Hughes. His first, breakthrough volume, *The Weary Blues* (1926), made Harlem speech sing and dance. In poems such as "Jazzonia," "Danse Africaine," "Trumpet Player," and "Midnight Dancer," he incorporated the rhythms of jazz and the phrasing of the blues.

Claude McKay created memorable riffs on jazz in poems such as "The Harlem Dancer" (1917), but his major contribution to music-inspired, and music-inflected, prose came in the novel *Home to Harlem* (1928), whose characters frequent clubs to hear singers like Congo Rose while "fooping or jig-jagging the night away."[10] Hurston wrote about taking a white friend to such a cabaret:

> This orchestra grows rambunctious, rears on its hind legs and attacks the tonal veil with primitive fury... until it breaks through to the jungle.... I dance wildly inside myself; I yell within. I whoop.... I want to slaughter something—give pain.... But the piece ends. ... I creep back slowly to the veneer we call civilization ... and find the white friend sitting motionless....

"Good music"… he remarks.…

… He is far away and I see him but dimly across the ocean and the continent that have fallen between us. He is so pale with his whiteness then and I am *so* colored.[11]

Hurston, one of the most celebrated Harlem writers, was also a choreographer and, at times, a dancer herself. She appeared in theatrical revues and later wrote and choreographed several of them, including *The Great Day* (1932), which had a brief run on Broadway. Some of her central characters are accomplished musicians, and the hero of *Jonah's Gourd Vine* (1934), her first novel, owes his success as a preacher to his booming baritone and cadenced delivery of his sermons. As the daughter of a minister, Hurston knew the power of gospel and church music in the black community, and she was aware how that music retained elements of the down-and-dirty blues.

Nella Larsen's novel *Quicksand* (1928) limns the mercurial changes of mood, and feelings of fitting in, of the mixed-race central character as she reacts to black musical performance. A minstrel show in her mother's native Denmark causes her allegiance to her blackness to come to the fore; back in New York, gospel music that she hears in a church sends her into a trance—and marriage to a black preacher—and she sways and dips to jazz bands in nightspots. Rudolph Fisher's *Walls of Jericho* (1928) and Wallace Thurman's *Infants of the Spring* (1932) are romans à clef that depict characters dancing their way through fabled venues such as the Savoy Ballroom (detail, p. 12) and the Manhattan Casino.

Hughes gave us the "jazz, jive, and jam"[12] of the urban centers; Hurston mostly presented the bluesy jooks and workcamp songs of Florida, where she had grown up. Sterling Brown, however, whose great poetry emerged in the 1930s, late in the Harlem Renaissance, drew on the musical traditions of both the North and the South to fully display the deep linguistic and rhythmic imprint of African American music on black writers. His poem "Ma Rainey" (1932) has an analogue in Reginald Gammon's lithograph *Ma Rainey, Empress of the Blues* (2001), one of Gammon's numerous prints of Harlem Renaissance jazz and blues musicians.[13]

Ezra Pound commanded modernism to "make it new"; this meant translating old forms into new ones. As this brief survey and the exhibition it accompanies indicate, African American modernists—the musicians, writers, and artists of the Harlem Renaissance—indeed made the old new. The interplay during these years between music and literature is only one example of how African American innovators in Harlem incorporated, alluded to, and adapted their heritage.

NOTES

1. It should be emphasized that many of the performers in Harlem, and elsewhere, brought what had been primarily southern musical forms with them to the big northern cities. Massive immigration to the North had begun in the waning decades of the nineteenth century—a low point in racial relations across the South, when the Ku Klux Klan sought to keep Jim Crow laws in place, and lynching was a regular occurrence. New factories in the North, especially steel mills in Pittsburgh, began to hire black workers. This Great Migration, as the movement northward came to be called, gathered speed with the advent of World War I; white Americans worried that German and Austrian spies would infiltrate America, so the government put a stop to European immigration. With immigration blocked, US factories, which provided armaments to Europe well before America entered the war, sent recruiters to the South, and soon northbound trains were taking entire communities of black rural workers to new lives in tenements and factories. Naturally, these migrants brought their musical forms with them, especially those from the Mississippi Delta, coastal Louisiana, and New Orleans.

2. In the 1920s, jazz became an international language, particularly in France, which developed an appetite for "le jazz hot," especially after black artists such as Bricktop, Sidney Bechet, and Josephine Baker immigrated there. Black nightclubs in Paris were complemented by revues, such as Baker's famous "Revue nègre."

3. Upper-class blacks sometimes viewed the new music as "low" and "common" in comparison to "high" European musical traditions. Part of the problem was the term "jazz," which the earliest performers didn't particularly like. "Jass" was a word for the sexual act that had its origins in New Orleans's notorious Storyville prostitution district. Early Crescent City jazz piano players performed there. Louis Armstrong grew up in Storyville; at age thirteen he was delivering coal to prostitutes. Thus cultural connotations gave the new music a bad name, though Leopold Stowkowski, the celebrated conductor, liked it, and during the twenties, most of the young writers, artists, and intellectuals embraced it as part of what Langston Hughes called the "vogue in things Negro." Hughes, "The Negro Artist and the Racial Mountain," in *The Collected Works of Langston Hughes*, vol. 9, *Essays on Art, Race, Politics, and World Affairs*, ed. Christopher C. De Santis (Columbia: University of Missouri Press, 2002), 34. Hughes's essay was originally published in 1926, in *The Nation*.

4. The song, written by Nat King Cole and Irving Mills, was famously performed by Fats Waller.

5. Throughout *Black Music* (New York: William Morrow, 1967), Amiri Baraka uses the term "the changing same" to describe the interplay between tradition and the individual musical talent. The phrase has been widely employed in African American literary criticism to describe the writer's obligation to honor tradition while at the same time providing something new.

6. Langston Hughes, *The Big Sea: An Autobiography* (1940; repr., New York: Hill and Wang, 1993), 223.

7. For the Harmon Foundation and its patronage of African American artists, see Natalie A. Mault's essay in this volume.

8. For more on the dancing figure in Harlem Renaissance art, see Margaret Rose Vendryes's essay in this volume.

9. Arna Bontemps, "The Two Harlems," *American Scholar* (Spring 1945): 168.

10. Claude McKay, *Home to Harlem* (New York: Harper, 1928), 30.

11. Zora Neale Hurston, "How It Feels to Be Colored Me," in *I Love Myself When I Am Laughing… And Then Again When I Am Looking Mean and Impressive: A Zora Neale Hurston Reader*, ed. Alice Walker (Old Westbury, NY: Feminist Press, 1979), 154.

12. "Jazz, Jive, and Jam" is the title of a short story in Hughes's collection *The Best of Simple* (1961).

13. Although often considered a Harlem Renaissance artist, Gammon (1921–2005) was born during the latter part of the era. His artistic career is more closely aligned with the civil-rights movement of the 1960s. In Gammon's work toward the end of his life, he highlighted cultural heroes in the African American struggle such as jazz musicians and gospel singers. Gammon's prints of Harlem Renaissance musicians can be seen on the artist's website (http://www.reggiegammon.com/worksonpaper.html) and at the Stella Jones Gallery, in New Orleans.

Hearing the Blues in the Art of the Harlem Renaissance

R. A. Lawson

The Harlem Renaissance could not have happened in the South, but it could not have happened *without* the South. The South's Jim Crow laws—like the slavery regime that preceded them, a culture of confinement and control—gave birth to a language of codes and signifying, a desire to move freely, and a need to recapture past identities that had been lost. African Americans' experiences of that oppression, and their resistance to it, were bound up in the blues: the musical locus of southern blacks' epistemology and aesthetics. Aaron Douglas celebrated the special status of the blues when he visualized music as *the* African American creative force in *Play de Blues* (1926; cat. 13). Langston Hughes understood that status when he wrote "I, Too, Sing America" (1924) and later titled his first volume of work *The Weary Blues* (1926). Zora Neale Hurston acknowledged it when she described the jook as "the most important place in America." With what Richard Wright called "lusty, lyrical realism," blues music articulated the zeitgeist of southern African Americans as well as any form in their cultural repertoire.[1]

But the blues do not give up their creators' secrets easily. Signifying—a West African–derived form of trickster mimicry and indirection—became a powerful veiling technique for coding language. As slaves, and then as second-class citizens under Jim Crow, black southerners developed richly sarcastic and bitterly ironic tropes, and the blues became a repository of lyrical codes. Some were humorous, such as "the peaches I'm lovin'... don't grow on no trees," while others mitigated pain, such as the lover's resignation to infidelity expressed by "another mule kicking in my stall." Some poked fun at the black community— "I'm gonna get me religion, I'm gonna join the Baptist church; / I'm gonna be a Baptist preacher, and I sure won't have to work"—but perhaps most useful of all were tropes

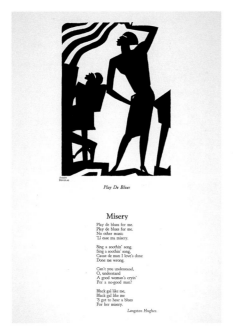

Play De Blues

Misery

Play de blues for me.
Play de blues for me.
No other music
'Ll ease ma misery.

Sing a soothin' song.
Sing a soothin' song,
Cause de man I love's done
Done me wrong.

Can't you understand,
O, understand
A good woman's cryin'
For a no-good man?

Black gal like me,
Black gal like me
'S got to hear a blues
For her misery.

Langston Hughes.

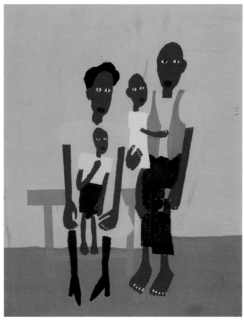

that signified on racial injustice. Kokomo Arnold sang, in "Bo-Weavil Blues" (1935): "Now Mr. Boll-Weevil, if you can talk why don't you tell; / Say, you got poor Kokomo down here in Georgia catchin' a lot of hell."[2] It is up to the audience to figure out who is signified by Mr. Boll-Weevil. Is he the local sheriff? The boss man? White folks in general?

Owning one's story and creating counternarratives to the doctrine of the dominant culture necessitated this coding. But the result was the fragmented being cogently described by W. E. B. Du Bois in 1903:

> One ever feels his two-ness,—an American, a Negro; two souls, two thoughts, two unreconciled strivings; two warring ideals in one dark body, whose dogged strength alone keeps it from being torn asunder. The history of the American Negro is the history of this strife,—this longing... to merge his double self into a better and truer self. In this merging he wishes neither of the older selves to be lost.... He simply wishes to make it possible for a man to be both a Negro and an American.[3]

In many ways, a new, unified identity was made manifest by the artists of the Harlem Renaissance, but in 1903 it would have been hard to imagine *how* this could be accomplished. The mass migration to the North was not yet under way, but over the next three decades northern cities would become the crucibles in which the black "double-consciousness" could be reconciled.

In August Wilson's theatrical vignette of 1920s Chicago, *Ma Rainey's Black Bottom* (1982), the restless trumpeter Levee demarcates the "New Negro" (Alain Locke's moniker for the self-aware, culturally articulate African American of the post–World War I era) from the old with jazz. For this ambitious character, traditional African American music—the folksy repertoire that Ma Rainey records for white producers and that Levee labels "old jug-band shit"— is deferential, constrained, and *southern*. By contrast, jazz is an art form of personal independence requiring talent and is "*real* music"; furthermore, jazz is notably northern and urban. In Levee's mind, for African Americans to be truly free, they must leave the South behind.[4]

Real-life African American thinkers agreed. In 1917, Robert Abbot, the publisher of the *Chicago Defender* newspaper, called for a "Great Northern Drive," spurring the Great Migration of African Americans; nearly two million moved north before World War II. The mass migration of black southerners connected them to the deep American tradition of seeking opportunity on a frontier, for New York, Chicago, Pittsburgh, Detroit, and other northern cities were indeed urban frontiers and, as such, offered what Frederick Jackson Turner had claimed for the western frontier: a "perennial rebirth," a "fluidity of American life," and "new opportunities." In using the word "rebirth," Turner (writing in 1893) prefigured the Harlem Renaissance. Movement to Harlem was not merely northward but also *upward.*[5]

And so migration begat renaissance. In the confluence of the educated middle-class northerners and their rural southern counterparts within the burgeoning black neighborhoods, the "New Negro" was born. The recent jazz phenom Gregory Porter evoked the genesis of black modernity in his 2012 recording "On My Way to Harlem," singing,

 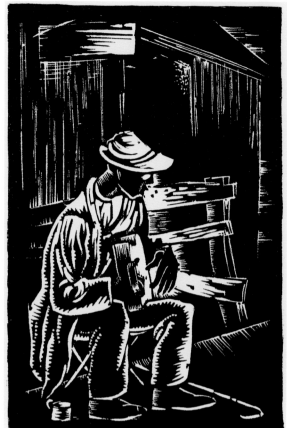

Cat. 15 Hale Woodruff (1900–1980), *Returning Home*, 1935, printed 1996.
From the portfolio *Selections from the Atlanta Period*. Linocut, sheet:
19 × 15 in. (48.3 × 38.1 cm), image: 10 × 8 in. (25.4 × 20.3 cm). Gibbes
Museum of Art, Charleston, SC, Gift of Reba and Dave Williams.

Cat. 16 Hale Woodruff (1900–1980), *Blind Musician*, 1935.
Woodcut, sheet: 19⁵⁄₁₆ × 15¹⁄₁₆ in. (49.1 × 38.3 cm), image:
6¹⁄₁₆ × 4¹⁄₁₆ in. (15.4 × 10.3 cm). Brooklyn Museum, NY, Gift
of E. Thomas Williams Jr. and Auldlyn Higgins Williams.

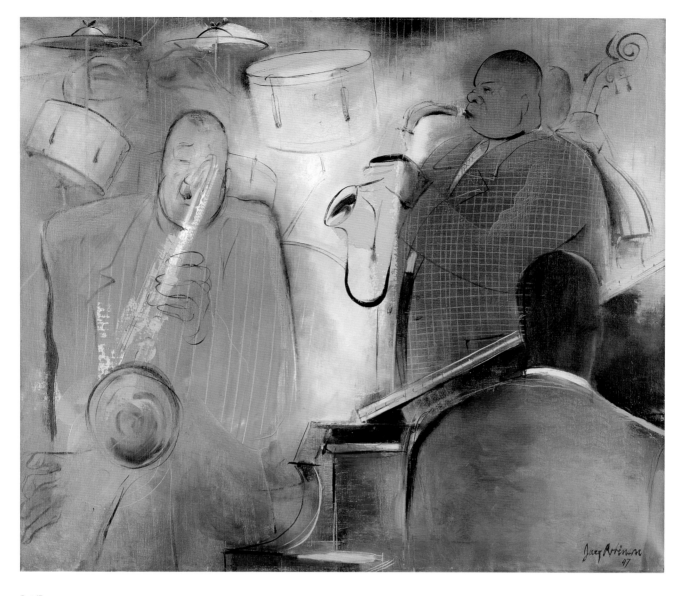

Cat. 17 Jay Robinson (b. 1915), *Jump Band (Pete Brown on Alto Sax)*, 1947. Oil on canvas, 34 × 40 in. (86.4 × 101.6 cm). Private collection.

Cat. 18 Jay Robinson (b. 1915), *Billie Holiday Singing the Blues*, 1947. Oil on canvas, 20½ × 16 in. (52.1 × 40.6 cm). Georgia Museum of Art, University of Georgia, Athens, Gift of Mr. and Mrs. Jason Schoen in honor of William Underwood Eiland.

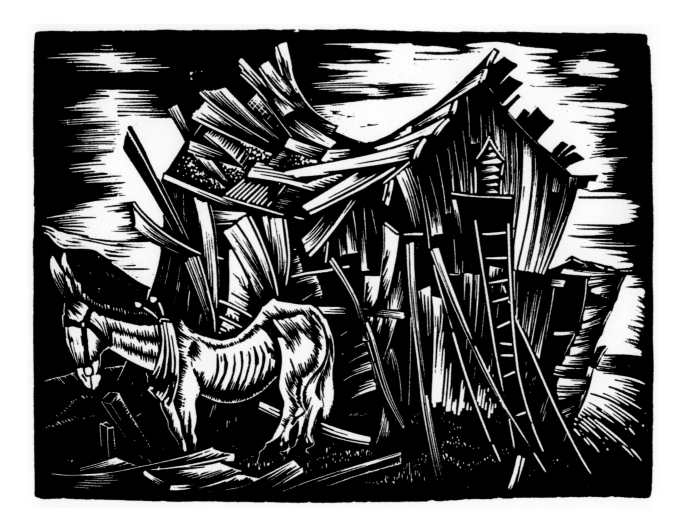

Cat. 19 Hale Woodruff (1900–1980), *Relics*, 1935, reprinted 1996. From the portfolio *Selections from the Atlanta Period*. Linocut, sheet: 15 × 19 in. (38.1 × 48.3 cm), image: 8 × 11 in. (20.3 × 27.9 cm). Gibbes Museum of Art, Charleston, SC, Gift of Reba and Dave William.

"You can't keep me away from where I was born; / I was baptized by the jazzman's horn." What was born, or metamorphosed to the sound of jazz, was, Locke said, a vibrant "new psychology" and "new spirit" that rejected the old objectification of the Negro for an emergent, autonomous subjectivity.[6]

The intellectual exchange was spirited. Musicians and writers commingled with visual artists, striving both to express a rich cultural past and to imagine a different present and future; together they forged an expectant and confident black culture that sought to redefine the possibilities of American freedom. "Our problem is to conceive... an art era," Douglas wrote to Hughes. "Let's bare our arms and plunge them deep through laughter, through pain, through sorrow, through hope, through disappointment, into the very depths of the souls of our people and drag forth material.... Then let's sing it, dance it, write it, paint it."[7]

But what would the art be like? The writer Harry Henderson noted that there "really could not be many African-American artists until the great migration," because "poverty and the isolation of rural life prevented access to the implements of painting and sculpture," and Locke observed in the mid-1920s that there had been "no development of a school of Negro art." But there was an ever-evolving body of vernacular music to draw from that, according to Amiri Baraka, "issued directly from the dictates of [African Americans'] social and psychological environment."[8]

So the visual blues did what the musical blues did, relating black life in black ways of knowing. Their stage was the same—the grifters' Saturday-night world of Hale Woodruff's *Card Players* (1930; cat. 20). The visual blues dramatize and signify. Bodies become expressive and interpretive instruments in Charles Alston's *Lindy Hop at the Savoy* (ca. late 1930s; detail, p. 12) and in William Henry Johnson's *Jitterbugs II* (1942; cat. 6). The visual blues create layers of sound, as in Jay Robinson's *Jump Band (Pete Brown on Alto Sax)* (1947; cat. 17). But they also have the musical blues' open-eyed realism about the instabilities of life and the isolation of the individual—see Woodruff's *Returning Home* (1935; cat. 15) and *Blind Musician* (1935; cat. 16).

And the visual blues *move*. Observers have long fixated on ramblin'—that bluesy wanderlust. While musicologists have linked blues musicians' peripatetic ways to itinerant musical traditions in sub-Saharan Africa such as the *jali* (griots), we might also consider that the desire to move—to be *free* to move—was a preoccupation among

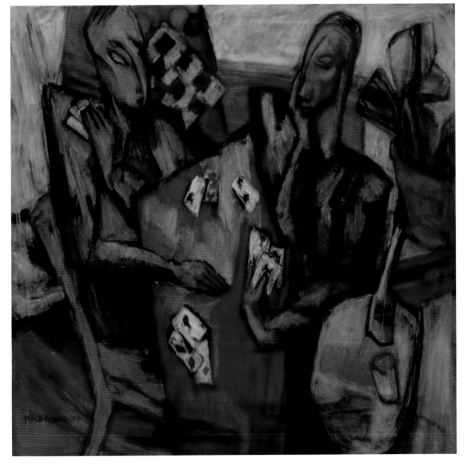

Cat. 20 Hale Woodruff (1900–1980), *Card Players*, 1930, repainted 1978. Oil on canvas, 36 × 42 in. (91.4 × 106.7 cm). Harvey B. Gantt Center for African-American Arts + Culture, Charlotte, NC.

Prentice Herman Polk (1898–1984), *William Christopher Handy*, 1942. Gelatin silver print, 9½ × 7½ in. (24.1 × 19 cm). National Portrait Gallery, Smithsonian Institution, Washington, DC.

southern blacks who had for centuries been immobilized and coerced into labor. The plantation economy had ultimately been a white hegemonic design to control black bodies. So while we can certainly identify songs about specific motivations for the northward migration—Son House's bemoaning a failing agrarian economy in "Dry Spell Blues" (1930) and Blind Blake's anticipating the "good jobs" offered by manufacturers in "Detroit Bound Blues" (1928)—there were also deeper, metaphysical urges to move. Consider Bessie Smith's famous recording of the W. C. Handy classic "St. Louis Blues" (1925), in which she sings, "[If I'm] feelin' tomorrow, like I feel today, / I'll pack my grip and make my get-away." Here, the choice to leave is paramount. This freedom is likewise central to the first "blues" song Handy heard in the Mississippi Delta, in 1903—an "unforgettable" tune about "Goin' where the Southern cross' the Dog." The lyric refers to the junction of two railways—a crossroads that allows a person to head off in any of four directions.[9] This freedom of choice is evoked in panel 59 of Jacob Lawrence's series *The Migration of the Negro* (1940–41; Museum of Modern Art, New York, and Phillips Collection, Washington, DC), wherein migrants

exercise their right to vote, something they were not able to do in the South.[10]

This spirit of unrestrained movement manifested itself in Harlem Renaissance–era dance in the same way that the freedom of musical creativity (improvisational solos, scat singing) resounded in jazz. These forms of expression— blues, spirituals, dance, and jazz—were, Ralph Ellison claimed, "what we had in place of freedom," and they became the basis of the visual art of the Jazz Age.[11] Douglas's *Judgment Day* (1927; cat. 37) virtually reverberates with rhythmic beats, and freely moving bodies dance across many Harlem Renaissance tableaux: Ellis Wilson's *Shore Leave* (1943; cat. 3), Charles Sallee's *Swingtime* (1937; cat. 50), and Faith Ringgold's *Groovin High* (1986; cat. 48), to name a few. And in these works of visual art, we see, feel, and, yes, perhaps even hear the blues—not only the freedom of movement but also the rhythms, the call-and-response, the signifying.

These rejoicings in movement are unrestrained celebrations of the self—to make whole what was fragmented, to free that which was contained. And so Douglas freed the African American past in works such as *Charleston* (ca. 1928;

North Carolina Museum of Art, Raleigh), *Building More Stately Mansions* (1944; Fisk University Galleries, Nashville), *Harriet Tubman* (1930; Bennett College, Greensboro, North Carolina), and the series *Aspects of Negro Life* (1934; New York Public Library, Schomburg Center for Research in Black Culture).[12] As artists of the visual blues, Douglas and his peers extracted from the musical blues the essentials of the black American experience and cultivated expressions and consciousnesses that had been sown in the West African past and germinated in the Deep South, but that flowered in the urban North.

NOTES

1. Zora Neale Hurston, "Characteristics of Negro Expression," in *Signifyin(g), Sanctifyin', and Slam Dunking: A Reader in African American Expressive Culture*, ed. Gena Dagel Caponi (Amherst: University of Massachusetts Press, 1999), 304; Richard Wright, foreword to *Blues Fell This Morning: Meaning in the Blues*, by Paul Oliver, 2nd rev. ed. (New York: Cambridge University Press, 1990), xv.

2. Peetie Wheatstraw, "Tennessee Peaches," Vocalion 1552 (Chicago, 1930); Otis Spann, "Mule Kicking in My Stall," Vanguard 6514 (Chicago, 1968); Son House, "Preachin' the Blues, pt. 1," Paramount 13013 (Grafton, WI, 1930); Kokomo Arnold, "Bo-Weavil Blues," Decca 7191 (Chicago, 1935).

3. W. E. B. Du Bois, *The Souls of Black Folk*, ed. David W. Blight and Robert Gooding Williams (Boston: Bedford/St. Martin's, 1997), 38–39.

4. August Wilson, *Ma Rainey's Black Bottom* (New York: Theatre Communications Group, 2007), 17.

5. Frederick Jackson Turner, "The Significance of the Frontier in American History," in *Rereading Frederick Jackson Turner*, ed. John Mack Faragher (New Haven: Yale University Press, 1998), 32.

6. Alain Locke, "The New Negro," in *The Harlem Renaissance*, ed. Harold Bloom (New York: Chelsea House, 2004), 161.

7. Aaron Douglas, quoted in Cary D. Wintz, ed., *Harlem Speaks: A Living History of the Harlem Renaissance* (Naperville, IL: Sourcebooks, 2007), 265.

8. Romare Bearden and Harry Henderson, *A History of African-American Artists: From 1792 to the Present* (New York: Pantheon, 1993), xv, 106 (Locke quote); Amiri Baraka, *Blues People: Negro Music in White America* (New York: Quill, 1963), 65.

9. W. C. Handy, *Father of the Blues: An Autobiography*, ed. Arna Bontemps (1941; repr., New York: Da Capo, 1969), 74.

10. For illustrations of Lawrence's *Migration* series, see the website of the Phillips Collection, http://www.phillipscollection.org /research/american_art/artwork/Lawrence-Migration_Series5 .htm.

11. Ralph Ellison, quoted in Jacqui Malone, *Steppin' on the Blues: The Visible Rhythms of African American Dance* (Urbana: University of Illinois Press, 1996), 37.

12. *Charleston, Harriet Tubman*, and the four works that make up *Aspects of Negro Life* are illustrated in Amy Helene Kirschke, *Aaron Douglas: Art, Race, and the Harlem Renaissance* (Jackson: University Press of Mississippi, 1995), nos. 62, 74, 79–82. For *Building More Stately Mansions*, see Susan Earle, ed., *Aaron Douglas: African American Modernist*, exh. cat. (New Haven: Yale University Press, 2007), pl. 17.

"Money, You've Got Lots of Friends"
Patronage in the
Harlem Renaissance

Natalie A. Mault

Reflecting today on the Harlem Renaissance produces a certain degree of nostalgia, but for African American writers, musicians, and visual artists of the time, the period was one of ongoing struggle in pursuit of creativity. With few opportunities for financial independence, many African Americans were forced to rely on the support of wealthy patrons. Although financial assistance from well-to-do supporters has always been a major source of income for artists, during the Harlem Renaissance the relationship between artist and patron was complicated by issues of race.

Opportunities for artists during the Harlem Renaissance varied greatly from individual to individual, but African American musicians arguably had the easiest time finding popular support.[1] As Harlem grew into the largest African American community in the nation, its reputation for entertainment and nightclubs increased accordingly. In the November 1928 edition of *Harlem* magazine, the directory "Where to Go and What to Do When in Harlem" listed four main attractions, including the nightclubs:

Opposite: Allan Rohan Crite (1910–2007), *Douglass Square* (detail of cat. 35), 1936. Oil on canvas-covered artist's board. Saint Louis Art Museum, MO, Gift of the Federal Works Agency, Work Projects Administration.

Among the best Harlem night clubs are the Cotton Club at 142nd Street and Lenox Avenue; the Lenox Avenue Club on Lenox Avenue, between 142nd and 143rd Streets; Cairo's on 125th Street, between Lenox and Fifth Avenues; the Sugar Cane at 135th Street and 5th Avenue; Small's at 135th Street and 7th Avenue; Barron's at 134th Street and 7th Avenue; Connie's Inn at 131st Street and 7th Avenue; Club Harlem at 129th Street and Lenox Avenue, and the Bamboo Inn at 139th Street and 7th Avenue.[2]

At these clubs (and many more), all located within a square-mile block in Harlem, white patrons sought out the performances of Count Basie, Ella Fitzgerald, Dizzy Gillespie,

41

and Louis Armstrong, among others, and black performers had the opportunity to attain financial stability and achieve broader recognition. Many African American musicians also received support from the growing recording industry, whose sales of race records—phonographic recordings of African Americans sold to black audiences—helped promote musicians nationwide. Race records grew in popularity with black *and* white listeners. Between 1920 and 1927, sales of the recordings exceeded $100 million.[3]

Unlike the Harlem Renaissance musicians, many African American writers and artists depended on personal relationships with wealthy patrons, not popular success, for financial support. A handful of nonwhite patrons emerged, but most artists and writers relied on relationships with white patrons.

For many Harlem Renaissance writers, patronage came from the American socialite Charlotte Osgood Mason (1854–1946). Mason's interest in supporting the black community grew from the belief that African Americans were untouched by white civilization—they were "rich sources of powerful, primitive, creative, and spiritual energies necessary to renew America."[4] In 1927, Mason took on the role of patron, or "godmother," as she insisted her protégés call her, after meeting the editor of *The New Negro* (1925), Alain Locke.[5] Through Locke, Mason met the authors Langston Hughes, Zora Neale Hurston, and Arthur Fauset and the artist Aaron Douglas, sponsoring them and many others who shared her belief in so-called primitivism or who simply needed her help.

Mason funded numerous writing and art projects, and financed opportunities to travel and study, but her generosity was accompanied by a certain amount of intervention and expectation.[6] She often sought to direct the creative efforts of black artists, pushing them to embrace their African roots and primitivism. For Langston Hughes, Mason's insistent approach eventually led to the end of his relationship with her. In his autobiographical writings, he lamented that he had "just been through a tense and disheartening winter after a series of misunderstandings with the kind lady who had been my patron. She wanted me to be more African than Harlem—primitive in the simple, intuitive, and noble sense of the word."[7] Hughes could not fulfill Mason's desire that he "know and feel the intuitions of the primitive":

> I did not feel the rhythms of the primitive surging through me, and so I could not live and write as though I did. I was only an American Negro—who had loved the surface of Africa and the rhythms of Africa—but I was not Africa. I was Chicago and Kansas City and Broadway and Harlem. And I was not what she wanted me to be. So, in the end it all came back very near to the old impasse of white and Negro again, white and Negro—as do most relationships in America.[8]

Aaron Douglas, too, endured a challenging association with Mason. Douglas met her in 1927, while he was finishing a mural project for Club Ebony. Aware of Mason's often

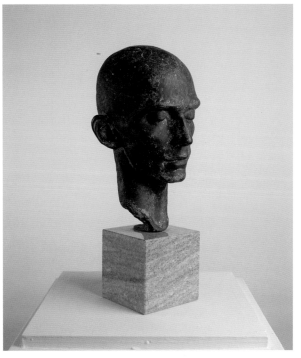

Cat. 22 Richmond Barthé (1901–1989), *Head of a Dancer*, 1937. Bronze, 18 × 7 × 6 in. (45.7 × 17.8 × 15.2 cm). SCAD Museum of Art, Savannah, Gift of Dr. Walter O. Evans and Mrs. Linda J. Evans.

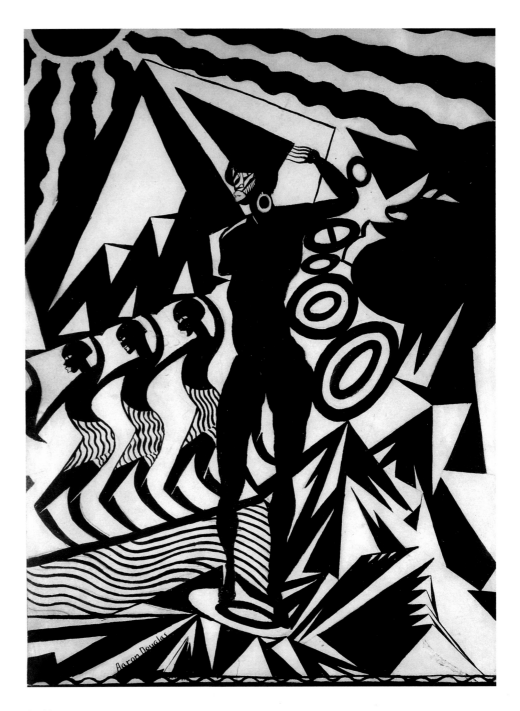

Cat. 23 Aaron Douglas (1899–1979), *Sahdji (Tribal Women)*, 1925. Ink and graphite on wove paper, 12¹/₁₆ × 9 in.
(30.6 × 22.9 cm). Howard University Gallery of Art, Washington, DC.

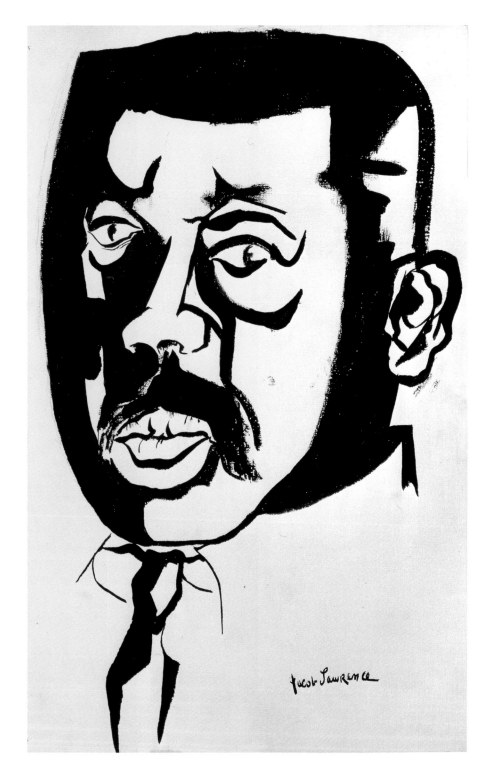

Cat. 24 Jacob Lawrence (1917–2000), *Self Portrait*, ca. 1965. Ink and gouache over charcoal, 19 × 12¹⁄₁₆ in. (48.3 × 30.6 cm). National Portrait Gallery, Smithsonian Institution, Washington, DC.

Cat. 25 Carl Van Vechten (1880–1964), *Alain Leroy Locke*, 1941, printed 1983. Photogravure, framed: 24 × 16 in. (22.4 × 15.1 cm). National Portrait Gallery, Smithsonian Institution, Washington, DC.

overbearing nature and desire to promote primitivism, Douglas nonetheless accepted her support, stating, "We follow the man that pays us."[9] Mason purchased artwork from Douglas and provided him with a monthly allowance, but her guidance often carried over into his personal life. In addition, Douglas did not always follow Mason's advice, as when he accepted a fellowship with Albert Barnes and a teaching position at Fisk University, in Nashville. In other cases, he found it harder to go against her wishes. As Douglas's biographer Amy Kirschke notes, "Mason convinced Douglas... not to accept the [Alfred A.] Knopf commission to illustrate [Carl Van Vechten's 1926 novel] *Nigger Heaven*. As a result, Douglas provided only the advertisements for [the] book, and his friendship with the author deteriorated"; it was "an action [Douglas] later regretted."[10] Over time, Douglas's relationship with Mason worsened, and he eventually broke with his patron to pursue his interest in abstraction.

Not all artists were subject to intrusive guidance from patrons. The sculptor Richmond Barthé, in Chicago, received financial support from a white patron who helped the young artist secure funding from the city's affluent black citizens.[11] Further assistance was provided by Barthé's local church, which funded his studies at the School of the Art Institute of Chicago. In 1930, the all-white Women's City Club of Chicago sponsored Barthé's first solo exhibition.[12] By the end of his career, Barthé had gained the support of numerous patrons, including the singers Josephine Baker and Gypsy Rose Lee, establishing a solid network of financial support.

The artist Hale Woodruff also received financial assistance from white patrons after he had gained artistic recognition through awards presented by the Indiana State Fair and through a series of exhibitions at the John Herron Art Institute (today the Herron School of Art and Design, Indiana University), in Indianapolis.[13] His artistic talents were honored locally by Governor Edward Jackson of Indiana, who presented Woodruff with a medal; by the Florentine Club of Franklin, Indiana, which organized a play and donated the proceeds to help fund the artist's travels in Europe;[14] and by many "friends and neighbors."[15] Woodruff even made a deal with a local art gallery, which promised to sell at least one of his paintings per month.[16] In 1926, national funding came from the esteemed Harmon Foundation, which awarded the young artist one hundred dollars. With these accumulated funds, Woodruff was able to finance an extended stay in Europe, but by 1928 his money was running low. He was forced to appeal for financial

assistance from the banker and patron of the arts Otto H. Kahn (1867–1934), who, like Woodruff, was in Paris at the time. After Walter Francis White (1893–1955), the assistant executive secretary of the National Association of Colored People, seconded Woodruff's request, Kahn agreed to contribute enough money to ensure Woodruff's survival for the two additional years the artist would remain in Europe.

Of all the artist-patron relationships that blossomed during the Harlem Renaissance, those involving Carl Van Vechten are some of the most astonishing. Van Vechten (1880–1964), a white critic of music and dance, a novelist, and a patron of the arts, grew up with what he called a "violent passion for things Negro,"[17] especially the culture and nightlife of Harlem. In Harlem's music halls and dance clubs he met everyone from W. E. B. Du Bois to Countee Cullen.[18] Van Vechten's background and social class afforded him the luxury to pursue this sort of social life. His unusual lifestyle earned him a reputation as a "white man amongst blacks."[19] As a novelist, he contributed to black periodicals such as *Opportunity: The Journal of Negro Life*, and as a patron, he sponsored literary competitions for black writers. Van Vechten even encouraged the publisher Alfred A. Knopf to publish Langston Hughes's blues-based poems. What greatly distinguished Van Vechten from other patrons was that he was an artist himself. By 1932, he was considered a serious New York photographer, and by his death, in 1964, he had amassed more than fifteen thousand photographs documenting the nightlife and celebrities of the period.

Equally fascinating, if far less common, are the relationships between Harlem Renaissance artists and black patrons. Charles S. Johnson (1893–1956) was an important black patron of the Harlem Renaissance writers Langston Hughes and Zora Neale Hurston, as well as the artist Aaron Douglas.[20] Johnson believed that the arts and literature were routes to independence and freedom for African Americans. Douglas met Johnson in 1924, while attending a National Urban League convention in Kansas City. Johnson served for years as Douglas's mentor, introducing him to Harlem's elite and educating him in proper etiquette. Douglas would later recall:

> I got to know Dr. Johnson quite closely, quite intimately. And ... on occasions of going to certain social things, certain parties, and so on when I might not have had exactly the right things, I'd borrow things from him. And that sort of relationship—he understood really what was going on, to add his strength to, to promote. Now, we see it as one of the greatest things that existed at that time and he promoted almost every young person at that time who had any talent whatsoever: these young people could be encouraged and could be pushed along by Dr. Johnson.[21]

Johnson supplied Douglas and many young African American artists with the opportunities, connections, and contacts they needed to succeed.[22] Johnson understood, said Douglas, "how to make the way, how to set the next step, how to indicate the next step for many of these young

people at that time and make it possible for them to go on to other things."[23] He even filled out and submitted Douglas's proposal to the Harmon Foundation for its annual award in fine arts.[24]

Institutions such as the Harmon Foundation took shape during the 1920s, offering support and opportunities in the United States for African American artists who might otherwise have sought to pursue their careers in Europe.[25] Their philanthropic efforts constituted a new kind of patronage.

The Harmon Foundation was established in 1922 by the self-made real-estate tycoon William E. Harmon (1862–1928), whose many visions for the foundation included charitable contributions for urban playgrounds, tuition assistance, vocational guidance for students, and educational programs for nurses, to name a few. In 1925, Harmon initiated the Awards for Distinguished Achievement among Negroes, to "give recognition over a five-year period to outstanding creative achievements of Negroes of American residence."[26] The object of the award was "to stimulate creative work in literature, music, fine arts, business including industry, science including invention, education, religious service, and race relations; to bring helpful public recognition to individuals of marked creative ability with preference to those whose work has not previously received such distinction."[27] In 1926, Harmon bequeathed nearly five hundred thousand dollars to endow the awards, and the foundation issued a national call to black artists to enter the first juried art competition.[28] Only nineteen artists responded,[29] but the following year the response more than doubled, with forty-one African American artists submitting work. As early as 1928, the Awards for Distinguished Achievement among Negroes were considered the main source of support for African American artists in the United States.

Increased submissions and the "excellent quality of submitted material in the field of Fine Arts" led the foundation to believe that the purpose of the awards would best be served by making the artwork available to the general public.[30] Given this new perspective, the Harmon Foundation's director, Mary Beattie Brady, suggested that an exhibition accompany the awards. In 1928, the foundation sponsored and organized the first nationally recognized, large-scale, juried art exhibition of works by African American artists[31] in conjunction with the awards, as well as a series of special prizes presented by other sponsors.[32] The Harmon Foundation's annual *Exhibit of Fine Arts Productions of American Negro Artists* was held at International House, at 500 Riverside Drive, in New York, in 1928, 1929, and 1930.[33] In 1931, the last year of the inaugural five-year period, the

Cat. 28 Carl Van Vechten (1880–1964), *Countee Cullen*, 1941, printed 1983. Photogravure, 8¾ × 5⅞ in. (22.3 × 14.9 cm). National Portrait Gallery, Smithsonian Institution, Washington, DC.

exhibition was held at the Art Center, at 65 East Fifty-Sixth Street, where there were "better facilities."[34] The new location, farther downtown, also brought a larger white audience to the exhibition.[35]

The four exhibitions between 1928 and 1931 presented almost five hundred works by more than 125 African American artists and traveled to fifty cities, reaching an audience of more than 150,000 people. When the Harmon Foundation's five-year program ended, Brady organized traveling exhibitions to black colleges and art centers throughout the country; she continued to do so until the Harmon Foundation offices closed in 1967.[36] The cash awards and publicity from these traveling exhibitions provided many artists with their only opportunity for artistic recognition. Since racial barriers prevented African American artists from showing their work in major galleries and museums, the Harmon Foundation's exhibitions were vital.

The first exhibition in support of African American artists to be held in a commercial gallery did not occur until December 1941. Downtown Gallery, in New York, held the exhibition *American Negro Art, 19th and 20th Centuries* between December 1941 and January 1942. The exhibition was sponsored by a committee of prominent citizens, including Countee Cullen, William Harmon, Mayor Fiorello La Guardia, Paul Robeson, Mr. and Mrs. John D. Rockefeller Jr., Eleanor Roosevelt, and Carl Van Vechten. It showcased seventy-five paintings, sculptures, and prints by "artists [of color] who attained some recognition,"[37] including Charles Alston, Richmond Barthé, Romare Bearden, Claude Clark, Allan Rohan Crite, Malvin Gray Johnson, Sargent Claude Johnson, William Henry Johnson, Jacob Lawrence, Archibald J. Motley Jr., Dox Thrash, Charles White, and Hale Woodruff. The exhibition raised money for the Negro Art Fund, and all sales commissions

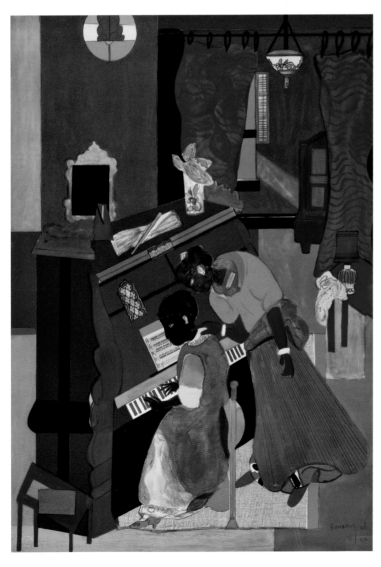

Cat. 29 Romare Bearden (1911–1988), *Piano Lesson*, 1986. Screenprint, sheet: 37 × 28¼ in. (94 × 71.8 cm), image: 29¼ × 20¼ in. (74.3 × 51.4 cm). California African American Museum, Los Angeles, Bequest of Alfred C. Darby.

were donated to the organization. Downtown Gallery also hoped the exhibition would inspire museums to acquire works by black artists and encourage galleries to represent living participants. Given these motives, it is puzzling that the only African American artist added to the gallery's own roster as a result of the show was Jacob Lawrence.[38]

By the start of the Great Depression, in 1929, patronage decreased alongside widespread financial hardship. Although the Harmon Foundation continued to provide opportunities to African American artists, the federal Works Progress Administration (WPA) quickly became artists' major patron. However, the projects proposed and organized as part of the New Deal relief effort established a new type of artistic production and subject matter. In the early 1930s, the Harlem Renaissance, and the relationships it had fostered between artists and private patrons, came to an end.[39]

NOTES

The line "Money, you've got lots of friends" is from the song "God Bless the Child" (1939), written by Billie Holiday and Arthur Herzog Jr.

1. The discrepancy between opportunities for musicians and opportunities for visual artists during the Harlem Renaissance was described by Aaron Douglas: "[T]here was no such thing as a painter at that time. You could sing, and we did create those marvelous spirituals. You could dance, but you didn't have any tools[,] any paper and that sort of thing, instructions and so on for doing things. They danced, and created dances that have lived and come right on up to this time. But, for the business of art, we had nothing to go on." Aaron Douglas, interview by Ann Allen Shockley, November 19, 1975, Black Oral History, Fisk University Special Collections, Nashville.

2. The three other main attractions in Harlem were listed as churches, gin mills, and restaurants.

3. Some visual artists took advantage of the success of the music and entertainment industries. Aaron Douglas painted the interior of the African Room at Club Ebony, which later reopened, at 388 Lenox Avenue, as Club Harlem—a "favorite retreat for the select and elite," according to *Harlem* magazine. Romare Bearden, too, capitalized on the opportunities afforded to African American musicians in order to fund his desire to be an artist. For sixteen years, Bearden's studio was located above the Apollo Theater, Duke Ellington became Bearden's first patron, and Bearden would later create an album cover for the jazz trumpeter Wynton Marsalis.

4. Aberjhani West and Sandra L. West, *Encyclopedia of the Harlem Renaissance* (New York: Facts on File, 2003), 211.

5. Mason asked to be called "Godmother" in order to maintain her anonymity. She served as Locke's patron for more than thirteen years. Mason sponsored him on trips around the world and purchased works for his collection of African art. Locke, in turn, took on the role of patron by promoting African American writers, musicians, and artists, including Loïs Mailou Jones and Jacob Lawrence. For more on Locke's *New Negro* anthology, see John Lowe's essay in this volume.

6. Estimates of her financial contributions range from $50,000 to $100,000—equivalent to $500,000 to $1 million today.

7. Langston Hughes, *I Wonder as I Wander: An Autobiographical Journey* (1956; repr., Columbia: University of Missouri Press, 2003), 40.

8. Langston Hughes, *The Big Sea: An Autobiography* (1940; repr., New York: Hill and Wang, 1993), 325.

9. Aaron Douglas, interview by L. M. Collins, July 16, 1971, Black Oral History, Fisk University Special Collections, Nashville.

10. Amy Kirschke, *Aaron Douglas: Art, Race, and the Harlem Renaissance* (Jackson: University Press of Mississippi, 1995), 37. Douglas's experience with the art collector and philanthropist Albert Barnes (1872–1951) was comparable to his involvement with Mason. Barnes supported African American artists both by purchasing works of art and through the Barnes Foundation, in Merion, Pennsylvania. In 1928, Douglas, along with his fellow *Fire!!* contributor Gwendolyn Bennett, received a fellowship to study at the foundation. In exchange, Barnes requested that Douglas and Bennett write an article criticizing Alain Locke. They did not, and that was the end of Barnes's patronage. Douglas, interview by Shockley, November 19, 1975.

11. This patron is identified as Dr. Charles Maceo Thompson, "a patron of the arts and supporter of many talented young black artists." Richmond Barthé papers, 1901–89, Amistad Research Center, Tulane University, New Orleans.

12. The patrons included Miss Zonia Baber, Miss Alice Boynton, Mr. Frank P. Breckinridge, Mr. and Mrs. Scott Cunningham, Mrs. C. Groverman Ellis, Mr. and Mrs. Philip Maher, Miss Mary McDowell, Mrs. Wm. Vaughn Moody, Mr. and Mrs. Fred Atkins Moore, Miss Florence Noyes, Mr. and Mrs. Walter Paepcke, Mr. and Mrs. Bernard Rodgers, Mrs. Irwin Rosenfels, Dr. and Mrs. Martin Schütze, and Dr. and Mrs. C. M. Thompson. The exhibition showcased twenty-six sculptures, including *Tortured Negro*, an impression of a mob victim in the South; *Jubilee Singer*; *The Breakaway*, a depiction of a Harlem cabaret entertainer; *Black Narcissus*, which shows a young Harlem singer; six portraits; and eight studies. (The present location of all these works is unknown.) Among the subjects of the portraits were several patrons, including Mrs. Scott Cunningham and Mrs. C. M. Thompson. In a handwritten note, Barthé recorded additional support from a patron: "$500 casting bill. New suit. By Frank Breckenridge, lawyer. Also financed first exhibition." The list of

patrons and works exhibited, as well as Barthé's note, are in the Barthé papers, Amistad Research Center, New Orleans, LA.

13. Woodruff exhibited his work in group shows at the John Herron Art Institute in 1923, 1924, and 1926.

14. The Florentine Club raised $200. Amalia Amaki, *Hale Woodruff, Nancy Elizabeth Prophet, and the Academy* (Seattle: University of Washington Press, 2007), 12.

15. One neighbor was Hermann Lieber, a German American who supported artists in the Hoosier Group.

16. Standard commissions from gallery sales at the time were at 33⅓ percent. A painting sold for $100 (the typical asking price) would have earned Woodruff $33.33, the equivalent of about $300 today.

17. West and West, *Encyclopedia of the Harlem Renaissance*, 258.

18. According to Aaron Douglas, "[Van Vechten] knew everybody in Harlem." Douglas, interview by Collins, July 16, 1971.

19. Emily Bernard, *Carl Van Vechten and the Harlem Renaissance* (New Haven: Yale University Press, 2012), 22.

20. Between 1919 and 1921, Johnson was hired by the Chicago Commission on Race Relations to contribute to the 672-page study *The Negro in Chicago: A Study of Race Relations and a Race Riot*. His reputation in the Harlem community rested on this in-depth study; his leadership at the National Urban League in New York, where he founded *Opportunity: The Journal of Negro Life*; and his continuing support of Harlem's writers and artists.

21. Douglas, interview by Collins, July 16, 1971.

22. Johnson helped introduce Douglas to important contacts such as Carl Van Vechten and Dorothy Barnes, from the Barnes Foundation. Kirschke, *Aaron Douglas*, 56.

23. Douglas, interview by Collins, July 16, 1971.

24. "Aaron Douglas (409 Edgecombe Ave, NY) / submitted with proposal of Aaron Douglas for Award in Fine Art / by Charles S. Johnson/127 E 23nd St. NYC." Harmon Foundation Printed Materials, 1928–63, container 74, Library of Congress, Washington, DC.

25. Even before the Harlem Renaissance, Paris had been a center of racial freedom for African American artists.

26. Eligible applicants were "Negro men and women of America." After an "experimental period" of five years, the success of the awards would be evaluated, and the program possibly modified or discontinued.

27. Written description, October 12, 1927, by E.S.B. (Evelyn S. Brown, assistant, public information): "Awards for Distinguished Achievement Among Negroes; Amount of the awards: $4,000 annually. The sum of $500 to be given in each of eight fields. In the first seven fields there will be a first award of $400 and a second award of $250. Gold medals accompany all first awards and a bronze medal to accompany all second awards. In addition, the Harmon Foundation agreed to: Furnish sum of $1,000 annually for administration expenses of the awards; Furnish sum of $4,000 for amount of awards; Pay costs of gold and bronze medals; Make recommendations as to the design to be used on the medals." Harmon Foundation Printed Material, 1928–63, container 1, Library of Congress, Washington, DC.

28. The awards were sponsored by the Harmon Foundation and administered in conjunction with the Commission on Race Relations.

29. Palmer Hayden (1890–1973) was awarded the first gold medal and $400; Hale Woodruff received the first bronze medal and $250.

30. Harmon Foundation Printed Material, 1928–63, container 64, Library of Congress, Washington, DC.

31. The Harmon Foundation is often credited with organizing the first exhibition of artworks by African American artists. It did not. One of the earliest documented exhibitions of works by an African American artist was in 1903, when the landscape painter Samuel O. Collins organized and exhibited his works in his home in Greenwich Village, New York, alongside works by the artist Eliza Hawkins. In 1917, the Arts and Letters Society of Chicago organized an exhibit of paintings by Archibald J. Motley Jr. In 1918, the Negro Library Association sponsored the first annual *Exhibition of Books, Manuscripts, Paintings, Engravings, Sculptures, et cetera.* These are just a few of more than a dozen exhibitions in the early twentieth century that featured works by African American artists. What distinguishes the Harmon Foundation's exhibitions is that they were the first to be recognized nationally for their support of African Americans and the African American art aesthetic.

32. Starting in 1928, Otto H. Kahn presented a special prize to "the best of work in the exhibition excluding that of the Awards winner." The prize was $250. In 1928, the prize was awarded to Sargent Johnson. In 1929, Malvin Gray Johnson received the award.

33. Harmon Foundation expenses for such exhibitions included $158 for hall rental for one month, $1,107.13 for catalogue expenses, $13.45 for the commission on sales of the catalogue, $250 for prizes, and $237.80 for opening-day expenses, printing, telegrams, and postage. Harmon Foundation Printed Material, 1928–63, container 64.

34. Harmon Foundation Printed Material, 1928–63, container 64.

35. The guest book for this final exhibition was signed by more than 1,550 people, from as far away as Chile, Bulgaria, and France. Notable signatures include those of Countee Cullen, W. E. B. Du Bois, Malvin Gray Johnson, Augusta Savage, Arturo Alfonso Schomburg, and Amy Spingarn. Harmon Foundation Printed Material, 1928–63, container 64.

36. During this period of traveling exhibitions, the Harmon Foundation amassed a significant collection of African American art.

Aaron Douglas was given funds by the foundation and charged with purchasing works by new and established African American artists. When the Harmon Foundation offices closed in 1967, the collection was dispersed among art museums and African American colleges and universities. More than 1,000 works were given to the Smithsonian Institution, 41 portraits were donated to the National Portrait Gallery, and a large portion of the collection was given to Fisk University, in Nashville, on extended loan. The care of the last remained with Mary Beattie Brady, at the Harmon Foundation, who sent Fisk University two thousand dollars annually for the conservation and general upkeep of the works. In 1977, Fisk moved the collection to the basement of Ballentine Hall, "until such a time that the storage conditions were so deplorable that a dry place had to be sought to house the works" (David C. Driskell to Nils Forstner, February 4, 1983, administrative files, Amistad Research Center, New Orleans). Then the works were moved to the basement of the Carl Van Vechten Gallery at Fisk. These actions displeased Brady, who in 1977 transferred custody of the loaned works to the United Church Board for Homeland Ministries. In 1985, the United Church Board granted legal ownership of the collection to the Amistad Research Center, in New Orleans. This collection, now known as the Aaron Douglas Collection, includes 270 examples by black and minority artists, most dating from between 1925 and 1954; among them are Malvin Gray Johnson's *Elks Marching* (1934), William Henry Johnson's *Jitterbugs II* (1942), Loïs Mailou Jones's *Rue Saint Michel* (1938), and Ellis Wilson's *Shore Leave* (1943). Margaret Rose Vendryes, "Art in the Archives: The Origins of the Art Representing the Core of the Aaron Douglas Collection from the Amistad Research Center" (master's thesis, Tulane University, 1992).

37. Downtown Gallery records, 1824–1974, Smithsonian Archives of American Art, Washington, DC.

38. Downtown Gallery records, 1824–1974.

39. Many Harlem Renaissance artists found support through the WPA, including Romare Bearden, Allan Rohan Crite, Aaron Douglas, Loïs Mailou Jones, Jacob Lawrence, Charles Sallee, and Dox Thrash.

Artist Biographies

Lauren Barnett and Natalie A. Mault

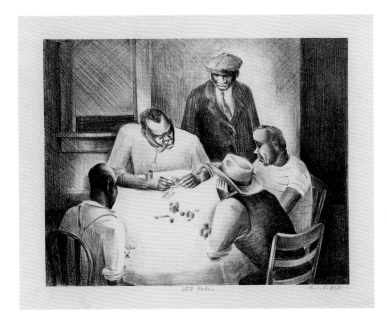

Cat. 30 Charles Alston (1907–1977), *Stud Poker*, 1935. Lithograph, sheet: 15⅜ × 19³⁄₁₆ in. (39 × 48.7 cm), image: 12¾ × 16⅛ in. (32.4 × 41 cm). Metropolitan Museum of Art, New York, Gift of New York City WPA, 1943.

CHARLES ALSTON
(Charlotte, NC 1907–1977 New York, NY)

The name of Charles Alston—a painter, muralist, sculptor, illustrator, and teacher—is synonymous with the Harlem Renaissance. Alston's family moved to New York City from North Carolina during the Great Migration, when Alston was a child. He cultivated his artistic interests in Harlem and received a bachelor's degree in fine arts from Columbia University and a master's degree from Columbia's Teachers College. His studio at 306 West 141st Street was associated with the Harlem Art Workshop and became an important meeting place for leaders of the Harlem Renaissance. The artists who gathered in Alston's studio called themselves the 306 Group; several of them, with Alston, founded the Harlem Artists Guild. He played a large role in promoting and mentoring young African American artists in New York, including Jacob Lawrence, who at age ten studied with Alston.

During the late 1920s, Alston joined a handful of artists (among them, Romare Bearden and Aaron Douglas) who publicly refused to participate in all-black exhibitions such as those sponsored by the Harmon Foundation. Alston maintained that the Harmon Foundation supported black artists whether they had talent or not. His opposition to segregated exhibitions would last throughout his career. In 1971, he declined the invitation to participate in the exhibition *Contemporary Black Artists in America* at the Whitney Museum of American Art.

In 1935, Alston became the first African American supervisor of a commission from the Federal Art Project of the Works Progress Administration. He oversaw the creation of a group of murals at Harlem Hospital and painted two murals in 1936 (the pair *Magic in Medicine* and *Modern Medicine*, today in the Mural Pavilion, Harlem Hospital Center). During this time, Alston continued to depict the cultural scene of Harlem, as in his rhythmic watercolor *Lindy Hop at the Savoy* (ca. late 1930s; detail, p. 12). The Lindy Hop reached its height in Harlem's famous Savoy Ballroom, a favorite haunt for Alston. Like the evolving jazz music of the age, the Lindy Hop was characterized by improvisation. Alston had an immense interest in jazz, spending much of his free time in clubs (alongside fellow North Carolinian, childhood friend, and, later, cousin-in-law Romare Bearden), and cultivated many close friendships with musicians in Harlem. During his career, Alston illustrated album covers for Duke Ellington (Bearden's first patron), and in 1933 his portrait sketch of Coleman Hawkins was published in *Melody Maker*, which claimed to be the world's oldest music magazine.

In 1938, Alston received a Rosenwald Fellowship. Making use of his fellowship to travel in the South, Alston shifted his attention to representing the lives of southern blacks. His earlier lithograph *Stud Poker* (1935; cat. 30) already shows his deep capacity for rendering rural life. Alston's artistic exploration of the South was cut short in 1942, when he was inducted into the military. As part of his work for the Office of War Information, he drew cartoons to promote the war effort. Back in New York, in the 1960s, Alston became a founding member of Spiral, a collective of African American artists formed in response to the civil-rights movement.

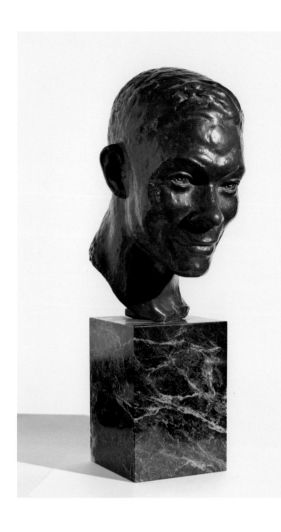

Cat. 31 Richmond Barthé (1901–1989), *Head of Jimmy Daniels*, ca. 1933. Bronze, 11½ × 6 × 8 in. (29.2 × 15.2 × 20.3 cm). Gibbes Museum of Art, Charleston, SC, Gift of Alan L. Wolfe.

RICHMOND BARTHÉ
(Bay St. Louis, MS 1901–1989 Pasadena, CA)

In 1915, the sculptor Richmond Barthé met a wealthy New Orleans family who invited him to work as their butler. Spending eight years in New Orleans expanded his cultural horizons, and he forged a friendship with the respected journalist Lyle Saxon, who reported for the *Times-Picayune*. Although Barthé had supporters who urged him to pursue the arts, he faced considerable racial prejudice in New Orleans. A search for greater professional opportunity prompted his move to Chicago, where in 1924 he gained admission to the School of the Art Institute of Chicago.

Barthé's training at the Art Institute gave him a strong foundation in the academic techniques of drawing and painting and in anatomy. He developed a novel approach to sculpture, keeping the human form while moving beyond the figure evoking states of emotion. Many of Barthé's sculptures evince his interest in African American dance and music. Two busts of performers, *Head of*

a Dancer (1937; cat. 22) and *Head of Jimmy Daniels* (ca. 1933; cat. 31), explore the confluence of the spirituality of movement and the physicality of the body.

Barthé moved to New York City in February 1929 and joined Harlem's artistic community. He quickly acquired fame and gained many opportunities to exhibit his work. After being awarded a Rosenwald Fellowship in 1931, and another in 1932, he established himself as the leading black sculptor in the United States and received major commissions. Barthé's national reputation was solidified when in 1933 his work was exhibited at both the Chicago World's Fair and the Biennial of the Whitney Museum of American Art, in New York. Barthé tired of his whirlwind life in the city, and in 1950 he moved to Jamaica, where he returned to painting. Jamaica was his home for more than twenty years, until he moved to Europe briefly before returning to the United States in 1977. Barthé lived in Pasadena, California, for the remainder of his life.

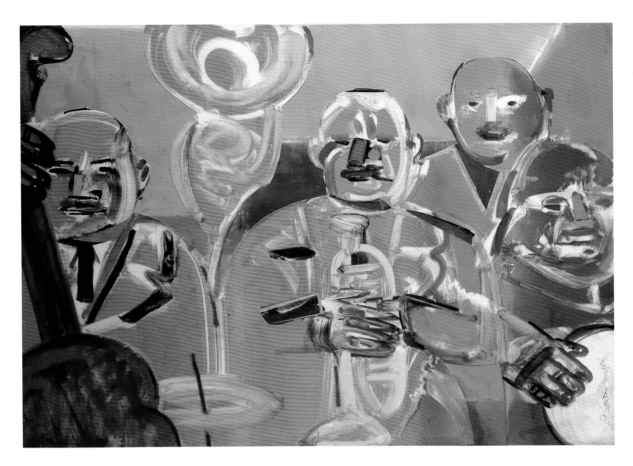

Cat. 32 Romare Bearden (1911–1988), *Twin Quartet*, 1981. Oil and collage on canvas, 30 × 36 in. (76.2 × 91.4 cm). Collection of Jumaane N'Namdi.

ROMARE BEARDEN
(Charlotte, NC 1911–1988 New York, NY)

Romare Bearden was a prolific artist whose oeuvre in many different media comprises more than two thousand known works. He was one of the many African Americans who migrated north in the early twentieth century. His family, who left North Carolina in 1914, was well connected in Harlem, where his mother served as founder and president of the Colored Women's Democratic League. He studied at Lincoln University, in Oxford, Pennsylvania; at Boston University, New York University, and New York's Art Students League; and at the Sorbonne, in Paris. Bearden started his artistic career in the early 1930s, when he became a member of the Harlem Artists Guild. During this time, he was introduced to African art, whose style influenced his later collage works. Bearden's work met with success and received national recognition. His first solo exhibition in Harlem was in 1940, and his first in Washington, DC, was in 1944.

In July 1963, a month before the March on Washington, led by the Reverend Martin Luther King, Jr., a group of black artists met in Bearden's studio to discuss the relationship of artists to the civil-rights movement and founded the Spiral collective. Although attendance at meetings quickly declined, the group was extraordinarily influential in the discourse of black artists both about aesthetic approaches and about art and politics.

Bearden's signature collages combine the rhythms of jazz and blues music with forms inspired by African art, Cubism, Mexican mural paintings, and the landscape of the Caribbean. Bearden had close ties to the musical world in Harlem. Duke Ellington, who was a second cousin and also one of his patrons; in the 1950s, he cowrote the chart-topping jazz classic "Seabreeze," which was recorded by Billy Eckstine, among others; and he married the dancer Nanette Rohan, the founder and artistic director of the Nanette Bearden Contemporary Dance Theatre, for which he would design programs and sets. Bearden's most profound connection with music, however, was his own artistic practice, in which references to music and musicians served as a refrain throughout his working life.

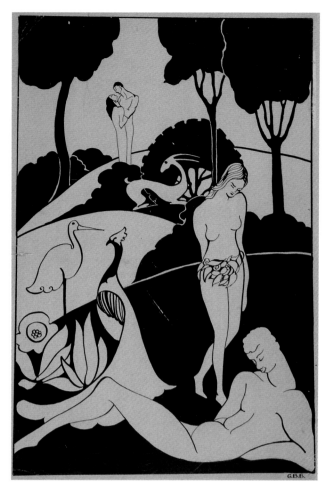

Cat. 33 Gwendolyn Bennett (1902–1981), *Adam & Eve*, 1932. Ink on paper, 18 × 13 in. (45.7 × 33 cm). Amistad Research Center, Tulane University, New Orleans.

GWENDOLYN BENNETT
(Giddings, TX 1902–1981 Reading, PA)

A visual artist, educator, poet, and writer, Gwendolyn Bennett moved with her family to Washington, DC, when she was a child. Bennett later studied art at Columbia University and Pratt Institute, in New York, and at the Sorbonne, in Paris. She went on to become a professor of fine arts at Howard University, in Washington, DC, as well as a frequent contributor of stories and poems to the influential journals *Opportunity: A Journal of Negro Life*, the publication of the National Urban League, and *The Crisis*, the official magazine of the National Association for the Advancement of Colored People. Awarded a scholarship to study abroad, Bennett moved to Paris in 1925.

In 1926, Bennett left Paris for Harlem. She was named an assistant editor of *Opportunity*. Bennett's politics were progressive, and she was outspoken, often putting her own artistic career on hold in order to further the careers of others. She worked for the Art Teaching Division of the Federal Art Project and established an art school for children in Harlem. Bennett fought against financial cutbacks by the Works Progress Administration, endeavoring to exempt African American artists from job layoffs. In the early 1940s, when she was the director of the Harlem Community Art Center, her leftist sympathies brought her into conflict with the House Un-American Activities Committee.

Bennett's poetry—for which she is best known—reflects her versatility in the arts and her abiding interest in African music, jazz, and the blues, which influenced her choice of themes and shaped the cadence of her stanzas.

Cat. 34 Claude Clark (1915–2001), *Jam Session*, 1943. Oil on canvas, 20 × 18 in. (50.8 × 45.7 cm). Philadelphia Museum of Art, Purchased with the Julius Bloch Memorial Fund created by Benjamin D. Bernstein, 1998.

CLAUDE CLARK
(Rockingham, GA 1915–2001 Oakland, CA)

Claude Clark grew up as one of ten children on a tenant farm in Rockingham, Georgia. He attended high school in Philadelphia and graduated from the Pennsylvania School of Industrial Art (now the University of the Arts). His early artworks offer romantic views of urban life in Philadelphia, and his sensitive scenes of the countryside caught the attention of critics. Clark worked in the Graphic Art Division of the Works Projects Administration from 1939 to 1942. During this time, he also met the collector Albert Barnes while studying at the Barnes Foundation, in Merion, Pennsylvania. Clark responded to the African influence on early European modernist painters, which in turn caused a dramatic shift in his own approach, as he endeavored to capture and incorporate African elements, as seen in the bold texture and color of *Jam Session* (1943; cat. 34).

After leaving the Barnes Foundation in 1944, Clark went to Talladega, Alabama, to build an art department at Talladega College, where he taught from 1948 until 1955. He received a fellowship from the Carnegie Corporation in 1950, and with these funds he traveled to Puerto Rico and the West Indies to paint. After moving to California, Clark earned his master's degree from the University of California, Berkeley, in 1962. In the mid-1960s, he moved to Oakland, California, where the artist Sargent Claude Johnson also lived. Clark taught history courses at Merritt College, in Oakland, until his retirement in 1981.

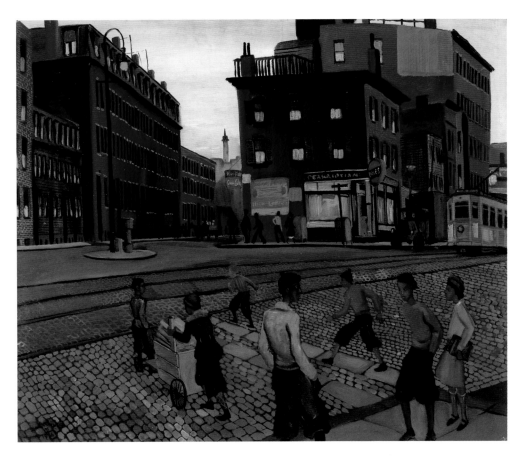

Cat. 35　Allan Rohan Crite (1910–2007), *Douglass Square*, 1936. Oil on canvas-covered artist's board, 23½ × 27 in.
(59.7 × 68.6 cm). Saint Louis Art Museum, MO, Gift of the Federal Works Agency, Work Projects Administration.

ALLAN ROHAN CRITE
(Plainfield, NJ 1910–2007 Boston, MA)

From 1929 to 1936, Allan Rohan Crite attended the School of the Museum of Fine Arts, Boston. Afterward he participated in a painter's workshop at the Fogg Art Museum, at Harvard, and earned a bachelor of liberal arts degree in 1968 from the Harvard University Extension School. Crite dedicated his career to depicting the social conditions of African Americans in Boston and to mentoring artists. He established a forum, called the Artists' Collective, to support younger black artists. During the 1930s, Crite was employed by the Works Progress Administration. In the following decade, he began work as a technical illustrator for the Department of the Navy and remained in that position for more than thirty years.

During the 1920s, illustrations by Crite were published in *Opportunity*, *The Crisis*, and *Survey Graphic* magazines. At this time, he began painting scenes from the urban black community. He rejected the figure of the southern sharecropper, scenes of social trauma, and the image of the black jazz musician in favor of depictions of day-to-day life in African American communities. *Douglass Square* (1936; cat. 35) is one of a series of neighborhood paintings Crite completed during the 1930s and 1940s, adding the people and places of the African American community of Boston's South End to the visual account of the black experience.

Cat. 36 Charles Cullen (1889–1963), *Illustration for "Color" (Tableau with Sunrays)*, 1925. Ink on paper, 26 × 35 in. (66 × 88.9 cm). Amistad Research Center, Tulane University, New Orleans.

CHARLES CULLEN
(Leroy, NY 1889–1963 place unknown)

Charles Cullen, a white illustrator, collaborated with many of the leading literary figures of the Harlem Renaissance. Cullen's Art Deco illustrations were featured inside and on the jacket of *Ebony and Topaz: A Collecteana* (1927), a literary anthology edited by Charles S. Johnson. Cullen illustrated many volumes of poetry by Countee Cullen (no relation) and, in 1933, an edition of Walt Whitman's *Leaves of Grass*.

While Cullen's female figures are physically accurate, his male figures are nearly androgynous forms lacking individualized features. This sexual ambiguity can be seen in his *Illustration for "Color" (Tableau with Sunrays)* (1925; cat. 36). *Color* (1925) was Countee Cullen's first published collection of poems. The ink-on-paper illustration presents a tableau of black and white figures dispersed among the geometric forms of sunrays. Confounding expectations about gender and race, Cullen's works suggest a commentary on the rigidity of social constructions. His figures are often distinguished by a highly charged eroticism. Although some in Harlem regarded Cullen with disdain because of his homosexuality and unorthodox lifestyle, he became a familiar figure in the community and among leaders of the black literary renaissance.

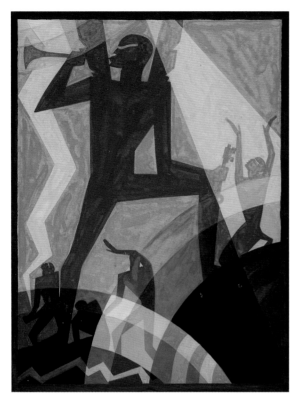

Aaron Douglas (1899–1979), *The Judgment Day*, 1927.
Gouache on paper, 11¾ × 9 in. (29.8 × 22.9 cm).
SCAD Museum of Art, Savannah, Gift of Dr. Walter O.
Evans and Mrs. Linda J. Evans.

AARON DOUGLAS
(Topeka, KS 1899–1979 Nashville, TN)

Aaron Douglas, an important advocate of the arts during
the Harlem Renaissance, was a promising artist by the
time he graduated from high school. He moved to Detroit,
working in the expanding automobile industry for several
months. The pride and hard work of the factory laborers
he encountered during his brief time there made a lasting
impact on his art; Douglas would go on to depict strong
and noble African American workers in his art. In 1918,
he moved west, to attend the University of Nebraska, in
Lincoln. He received a bachelor of fine arts degree in 1922
and, later, a master's degree in fine arts from Columbia
University.

Black literary magazines provided an impetus to Doug-
las's career. A 1925 issue of *Survey Graphic* magazine focus-
ing on the vibrant Harlem community inspired him to
move again, this time to experience for himself the "Negro
Mecca." Douglas's encounters with W. E. B. Du Bois,
Winold Reiss, and Charles S. Johnson furthered the alli-
ance between literary and artistic leaders that distinguished
the Harlem Renaissance. The scholar Alain Locke hired
Douglas to create illustrations for *The New Negro* (1925), an
expanded version of the *Survey Graphic* issue about Har-
lem. Douglas's illustrations, characterized by sharp lines
and geometric forms, African themes, and jazz influences,
are emblematic of the Harlem Renaissance. *Rise, Shine for
Thy Light Has Come* (1924; cat. 10) epitomizes the optimistic and
resilient attitude that accompanied black culture during the
advancement of the New Negro.

In 1930, Douglas turned to a new artistic challenge:
mural painting. He worked as an artist in residence at Fisk
University, in Nashville, Tennessee, creating a cycle of
murals about the accomplishments and struggles of black
Americans throughout history. The following year, he trav-
eled to France, where he joined a group of expatriate art-
ists, including Henry Ossawa Tanner. After spending more
than a year in Paris, Douglas returned home and enjoyed
the success of his first solo exhibition, at Caz Delbo Gal-
lery, in New York City.

In 1934, Douglas received commissions for murals from
the Works Progress Administration. The most famous
among them are the murals he created for the Harlem
branch (now the Schomburg Center for Research in Black
Culture) of the New York Public Library—*The Negro in an
African Setting*, *Slavery through Reconstruction*, *An Idyll of
the Deep South*, and *Song of the Towers*. The four panels, col-
lectively titled *Aspects of Negro Life*, incorporate powerful
themes from Africa, the Deep South, and modern America
and exemplify Douglas's virtuosity.

Cat. 38 John Gutmann (1905–1998), *Untitled*, 1936. Gelatin silver print, 7½ × 7¹⁵⁄₁₆ in. (19 × 20.2 cm). Center for Creative Photography, University of Arizona, Tucson.

JOHN GUTMANN

(Breslau, Germany [today Wrocław, Poland] 1905–1998 San Francisco, CA)

The photographer John Gutmann first trained as a painter in Berlin. In 1933, he emigrated to the United States to escape Nazi persecution. Before leaving Germany, he devised a plan to sell photographs of America to German picture agencies. Gutmann's decision to try photography was a purely financial one, but the artist discovered that he preferred the medium to painting. In America, Gutmann set out to chronicle the optimistic moments among the hard times of the 1930s. His background as a German Jew—an outsider—in the United States inspired his photographs of Asian American communities in California and African American communities in New York. Gutmann's work combines photojournalism with influences from avant-garde European photography.

After arriving in America, Gutmann began teaching art at San Francisco State College (now San Francisco State University). His part-time position allowed him to travel extensively, and he visited the nation's major cities. Gutmann went to New York City and began working for the agency Pix, Inc. During this time in New York, Gutmann captured aspects of musical life uptown. An untitled photograph by Gutmann (cat. 38) shows an advertisement for the Harlem Opera House—which closed in 1936, the same year the photograph was taken. During the Harlem Renaissance, the theater, which had been built in 1889 and had been off limits to black patrons until after World War I, was a showplace equal to the Apollo Theater and the Cotton Club. Many celebrated jazz musicians, including Ella Fitzgerald, performed there on amateur nights.

By 1937, Gutmann's photographs had appeared in major national publications such as the *Saturday Evening Post, National Geographic, Life, Time*, and *US Camera Annual*. In 1938, he was appointed assistant professor of art at San Francisco State College, where he would later establish a creative-photography program. He served overseas between 1942 and 1945, working with the US Office of War Information in the China–Burma–India theater after training as a motion-picture cameraman. Following his retirement from San Francisco State College in 1973, Gutmann devoted much of his time to editing and reprinting his large photographic oeuvre. He also published a book of his photographs from the 1930s, *The Restless Decade* (1984).

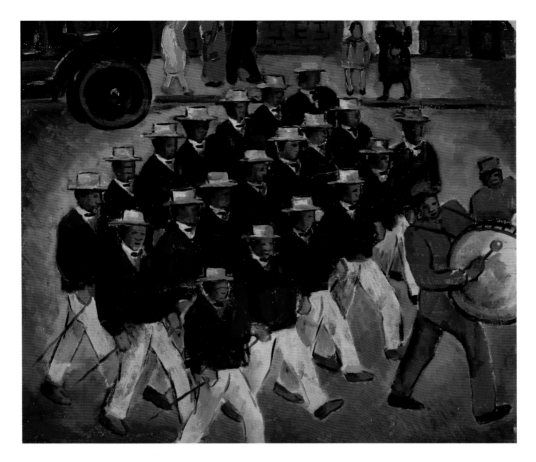

Cat. 39 Malvin Gray Johnson (1896–1934), *Elks Marching*, 1934. Oil on canvas, 16 × 19 in. (40.6 × 48.3 cm).
Amistad Research Center, Tulane University, New Orleans.

MALVIN GRAY JOHNSON
(Greensboro, NC 1896–1934 New York, NY)

Malvin Gray Johnson moved from North Carolina to Harlem in 1912 to further his artistic education. He studied at the National Academy of Design (now the National Academy Museum and School), in New York, and first achieved artistic recognition in 1928, when the Harmon Foundation gave him first prize for his painting *Swing Low, Sweet Chariot* (private collection). In his work, Johnson sought to reconcile traditional and modernist styles.

Elks Marching (1934; cat. 39) demonstrates Johnson's interest in Cubism. The perspective of the scene is tilted up; the human forms of the marching men are flat, geometric abstractions, one repeating the other. Nonetheless, a parade through the neighborhood by members of Harlem's fraternal societies and social organizations was a regular occurrence, and a subject Harlem residents would recognize. Denied membership in the white Benevolent and

Protective Order of Elks, African Americans had founded their own Elks lodges, to which both educated and working-class black men belonged. Johnson's Elks are emblems of Harlem's racial pride and unity.

In 1934, Johnson traveled to Brightwood, Virginia, where he depicted the lives of rural African Americans. This was the first time that he artistically explored his southern roots. The paintings he made during his trip were in preparation for a solo show at the Delphic Studios (a New York gallery owned by the journalist Alma Marie Sullivan Reed). This exhibition would have placed Johnson among a small group of African Americans who were able to display their work in a contemporary art gallery. However, the exhibition never came to fruition because of Johnson's untimely death that year, at the age of thirty-eight.

The Aaron Douglas Collection at the Amistad Research Center, at Tulane University, in New Orleans, holds twenty-three of Johnson's paintings, making it the largest repository of his art in the nation.

Singing Saints 59/150 *Sargent Johnson*

Cat. 40 Sargent Claude Johnson (1888–1967), *Singing Saints*, 1940. Lithograph, sheet: 26½ × 19½ in. (67.3 × 49.5 cm), image: 12 × 9¼ in. (30.5 × 23.5 cm). California African American Museum, Los Angeles.

SARGENT CLAUDE JOHNSON
(Boston, MA 1888–1967 San Francisco, CA)

Born in Boston, Sargent Claude Johnson was raised in Washington, DC, by his aunt, the sculptor May Howard Johnson, who interested her young charge in her chosen art. He moved to San Francisco in 1915 to study at the A.W. Best School of Art and the California School of Fine Arts (now the San Francisco Art Institute) and quickly gained local recognition. In 1925, and again in 1931 and 1935, the San Francisco Art Association awarded Johnson prizes for

his work. By 1930, he was a prominent regional artist, having also won the Harmon Foundation's Otto H. Kahn Prize in 1927 and the Harmon Foundation's bronze award for fine arts in 1929.

Johnson worked in a variety of media, including mosaic murals, enamel, and ceramic. Throughout his work, he endeavored to interest African Americans in their heritage and instill a sense of pride in their racial features. Beginning in the late 1940s, Johnson shifted his focus from African American subjects to themes inspired by his travels to Mexican archaeological sites.

Cat. 41 William Henry Johnson (1901–1970), *Sowing*, ca. 1942. Screenprint, sheet/image: 11½ × 16 in. (29.2 × 40.6 cm). Gibbes Museum of Art, Charleston, SC, Museum Purchase with funds provided by the Anna Heyward Taylor Fund.

WILLIAM HENRY JOHNSON
(Florence, SC 1901–1970 Central Islip, NY)

William Henry Johnson depicted the history and traditions of black culture in the South and in Harlem. In 1918, he moved to New York City, where he attended the National Academy of Design (now the National Academy Museum and School). He traveled to France in 1926, to learn about modern art movements. In 1929, the Harmon Foundation recognized Johnson with a gold medal. He briefly returned to the United States in 1930, opened an art studio in Harlem, and traveled to South Carolina, where he was arrested for painting in a public square—a crime for a black man in the Jim Crow South. That same year, Johnson returned to Europe, settling in Denmark, where he married the Danish artist Holcha Krake. Although he lived abroad, Johnson remained active in New York, exhibiting his paintings with the Harmon Foundation in 1930, 1931, and 1933. After spending more than a decade as an expatriate in Europe,

Johnson moved back to the United States in 1938, intent on representing African American life, folklore, and culture in his work.

Johnson's childhood in rural South Carolina provided a constant source of inspiration for his paintings. Johnson experimented with various painting media and printmaking techniques. He made several versions of his painting *Sowing* (ca. 1940; Morgan State University, Baltimore), which today are in collections around the country, as well as a screenprint of the composition (ca. 1942; cat. 41). The scene is a result of Johnson's contemplation of rural southern life; farm life and farm labor were frequent subjects (see his *Folk Family,* 1942; cat. 14).

Johnson also created more than twenty works, in a number of media, devoted to five different steps of the jitterbug. The screenprint *Jitterbugs II* (1942; cat. 6), from this series, conveys the frenetic energy of the dance craze and the dynamism of the Harlem Renaissance.

Loïs Mailou Jones (1905–1998), *A Student at Howard*, 1947. Watercolor over graphite, 20 × 14 in. (50.8 × 35.6 cm). Bowdoin College Museum of Art, Brunswick, ME, Gift of Eliot O'Hara.

Loïs Mailou Jones
(Boston, MA 1905–1998 Washington, DC)

Loïs Mailou Jones attended the School of the Museum of Fine Arts, Boston, and began her career as a textile designer. She switched her focus to painting and in 1928 became the chair of a new art department at the Palmer Memorial Institute, a high school for African American students in North Carolina. In 1930, she joined the faculty at Howard University, in Washington, DC. Although Jones never lived in Harlem, during her time at Howard (she retired in 1977) she traveled frequently to New York City, where she associated with important figures of the Harlem Renaissance including Langston Hughes, Arthur Schomburg, and Dorothy West.

Jones received a grant from the General Education Board in 1937, which allowed her to travel to Paris on a sabbatical year in 1938. There she spent time painting *en plein air*, creating works such as *Rue Saint Michel* (1938; cat. 27), a depiction of Parisian street life. Jones enjoyed the social freedoms granted to her in France and flourished there as an artist. In 1939, following her return to the United States, she was honored with a solo exhibition at the Robert C. Vose Galleries (now Vose Galleries of Boston). Jones had shown her paintings in exhibitions of African American art sponsored by the Harmon Foundation, but she was determined to transcend the bounds imposed on her by racial bias in America. She submitted works to major museum shows and competitions (from which African American artists were excluded), once under the name of a white colleague.

Throughout the 1930s, Jones collaborated extensively with writers, working as a book illustrator. In 1935, she created thirty-six illustrations for *The Picture Poetry Book*, by Gertrude Parthenia McBrown, and in 1938 she completed thirty illustrations to accompany the text of *African Heroes and Heroines* (1939), by Carter G. Woodson. Jones also provided illustrations for widely read publications such as the *Journal of Negro History* and the *Negro History Bulletin* (today the *Journal of African American History* and the *Black History Bulletin*, respectively).

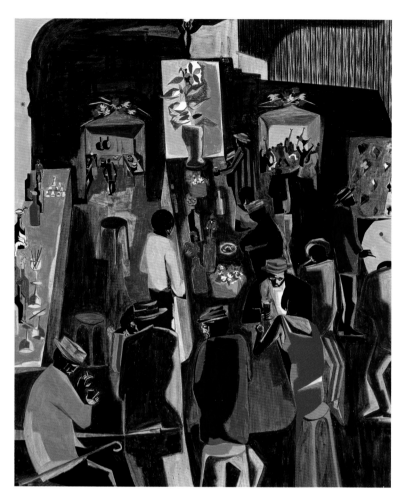

Cat. 43 Jacob Lawrence (1917–2000), *The Brown Angel*, 1959. Tempera on gesso panel, 23⁵⁄₁₆ × 19¼ in. (59.2 × 48.9 cm). Museum of Fine Arts, Houston, TX, Gift of the Caroline Wiess Law Foundation, with additional funds provided by the African American Art Advisory Association and ExxonMobil.

JACOB LAWRENCE
(Atlantic City, NJ 1917–2000 Seattle, WA)

Jacob Lawrence moved to Harlem in 1930. He was one of the first African American artists trained in and by the Harlem artistic community: he attended the Harlem Art Workshop (1932–39), the Harlem Community Art Center (1936), and the American Artists School (1937–39). Two of Harlem's leading artists—the painter Charles Alston and the sculptor Augusta Savage—were his mentors.

When he was in his early twenties, Lawrence completed a series of sixty panels called *The Migration of the Negro* (1940–41; Museum of Modern Art, New York, and Phillips Collection, Washington, DC). In these paintings, he depicted the mass migration of African Americans from the rural South to the industrial cities of the North between World War I and World War II. His compositions melding realism and abstraction illustrate the injustices and hardships of African American life in the South and the life that migrants found in the North. The series was first exhibited in 1941, at Downtown Gallery, in New York; it was shown around the country in a traveling exhibition from 1942 to 1944. During an age of legalized segregation and racial prejudice, Lawrence managed to gain support from mainstream museums and patrons.

Throughout his career, Lawrence painted the African American experience—in views of street life and domestic interiors and in depictions of labor and leisure. In 1970, the National Association for the Advancement of Colored People recognized Lawrence's artistic achievement by presenting him with its Spingarn Medal—the only time the award has been given to a visual artist since the medal's institution in 1914.

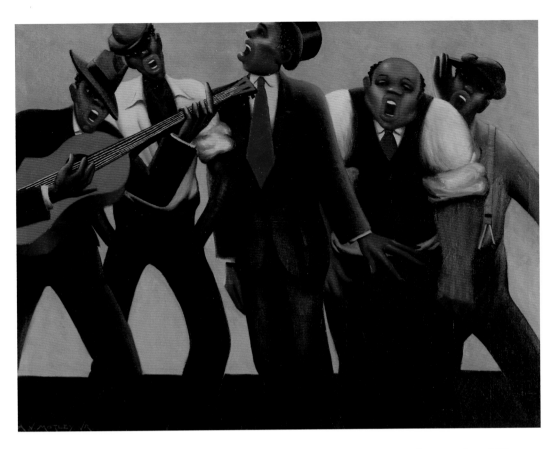

Cat. 44 Archibald J. Motley Jr. (1891–1981), *Jazz Singers*, ca. 1934. Oil on canvas, 32 × 42 in. (81.3 × 106.7 cm). Western Illinois University Art Gallery, Macomb, Courtesy of the Fine Arts Program, Public Buildings Service, US General Services Administration, Commissioned through the New Deal art projects.

ARCHIBALD J. MOTLEY JR.
(New Orleans, LA 1891–1981 Chicago, IL)

Although Archibald J. Motley Jr. is associated with the Harlem Renaissance, he never lived in Harlem. Born in New Orleans, Motley lived in Louisiana for two years before his family migrated north, to an area of Chicago's South Side that later became known as Bronzeville. The Motleys lived in a racially tolerant community, and in 1924 Motley married a white woman, Edith Granzo. A graduate of the School of the Art Institute of Chicago, Motley exhibited his work in 1928 with the Harmon Foundation. In the same year, he had a solo exhibition at New Gallery, in New York, becoming one of the first African American artists to have a show in a mainstream gallery. The *New York Times* reported on his artistic success on the front page of its February 25, 1928, edition.

Motley received a Guggenheim Fellowship in 1929 and used the grant to spend a year in Paris. While there, he painted *Blues* (1929; private collection), which depicts dancers and musicians in a Parisian jazz club. Motley returned to Chicago in 1930, painting *Jazz Singers* (ca. 1934; cat. 44) shortly thereafter. Throughout the 1940s, he continued to depict the exuberance and vitality of jazz culture in Chicago's Bronzeville neighborhood.

BARNETT AND MAULT

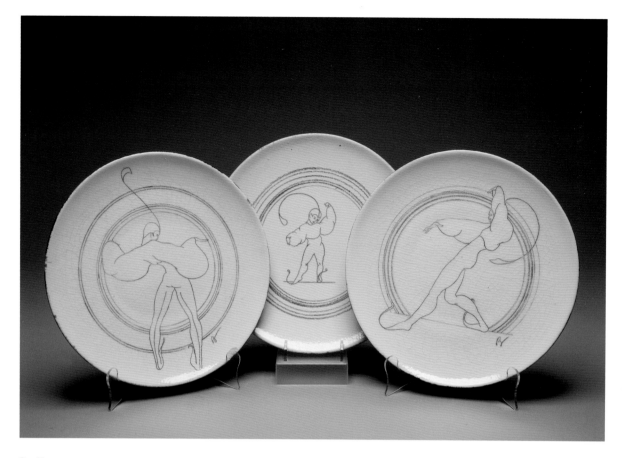

Cat. 45 Richard Bruce Nugent (1906–1987), *Three Plates with Designs of Dancing Figures*, 1952. Ceramic, diam. 9 in. (22.9 cm) each. Amistad Research Center, Tulane University, New Orleans.

RICHARD BRUCE NUGENT
(Washington, DC 1906–1987 Hoboken, NJ)

Richard Bruce Nugent was born into one of the socially elite African American families of Washington, DC. Although the Nugents were not affluent, they were progressive and welcomed many artists and intellectuals into their home. Nugent's mother, Pauline Minerva Bruce Nugent, was an accomplished pianist and instilled a love of theater, music, and dance in her son from an early age. The Nugents attended performances of the Lafayette Players, an African American theater group geared toward the black audiences of Washington.

Nugent moved to New York in 1920 to begin his career as a writer, poet, and playwright, and he soon began experimenting with painting, drawing, and ceramics. His story

"Sahdji" appeared in Alain Locke's *New Negro* anthology (1925), with an illustration by Aaron Douglas, *Sahdji (Tribal Women)* (cat. 23). In 1931, Nugent and Locke adapted the story into a ballet, performed at the Eastman School of Music, in Rochester, New York. Nugent also collaborated with Gwendolyn Bennett, Douglas, Langston Hughes, and others on *Fire!!* (1926), a quarterly devoted to the work of African American artists and writers. *Fire!!* included two drawings by Nugent and his short story "Smoke, Lilies, and Jade." This story, written from an explicitly homoerotic perspective, was the first publication by an African American to openly depict homosexuality. Although the first issue of *Fire!!* proved to be its only issue, the volume was a significant contribution to the Harlem Renaissance.

Cat. 46 Marion Palfi (1907–1978), *New York, Social Work*, ca. 1946. Gelatin silver print, 9⅝ × 7¾ in. (24.4 × 19.7 cm). Center for Creative Photography, University of Arizona, Tucson.

MARION PALFI
(Berlin, Germany 1907–1978 Los Angeles, CA)

Marion Palfi's artistic career began in her birthplace of Berlin, where she apprenticed with a portrait photographer. Palfi fled Nazi Germany in 1936 and set up a portrait photography studio in Amsterdam. When the German army invaded the Netherlands in 1940, she fled yet again, this time to New York.

Palfi was startled by the racial tensions and racial intolerance she found in the United States. In 1944, she embarked on a photographic project to celebrate African American artists, *Great American Artists of Minority Groups and Democracy at Work*, sponsored by the Council Against Intolerance in America. This effort gained her both the support of Langston Hughes and, in 1946, a Rosenwald Fellowship. The photograph *New York, Social Work* (ca. 1946; cat. 46), from the series *Towards a Better Children's World*, demonstrates Palfi's ability to compress social commentary in a single shot: it shows two teenagers dancing at a community center in Harlem.

Prentice Herman Polk (1898–1984), *Catherine Moton Patterson (Woman Playing the Harp in an Evening Gown)*, 1936. Gelatin silver print, 14 × 11 in. (35.6 × 27.9 cm). California African American Museum, Los Angeles, Gift of P. H. Polk.

PRENTICE HERMAN POLK
(Bessemer, AL 1898–1984 Tuskegee, AL)

Prentice Herman Polk studied at Tuskegee Institute (now Tuskegee University) from 1916 to 1920, and he apprenticed with the commercial photographer Fred Jensen in Chicago from 1922 to 1926. From the late 1920s to the end of his life, Polk documented events at Tuskegee Institute, first as a photography instructor and later as Tuskegee's official photographer. His subjects include the scientist George Washington Carver at work—more than five hundred negatives survive—and well-known visitors to the campus such as the artist Aaron Douglas, the blues musician and composer W. C. Handy (1942; cat. 21), and the jazz composer and band leader Noble Sissle (1937; cat. 11). The harpist Catherine Moton Patterson, shown in a 1936 photograph (cat. 47), was the daughter of Tuskegee's second president and the wife of its third president. Polk also had a lucrative private portrait photography studio that was patronized by middle-class African Americans.

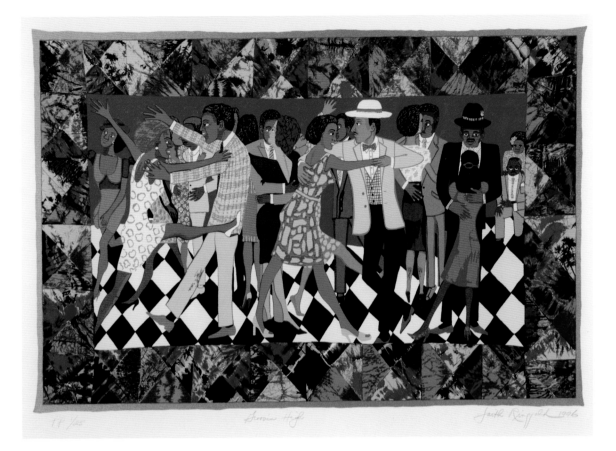

Cat. 48 Faith Ringgold (b. 1930), *Groovin High*, 1986. Screenprint, sheet: 23½ × 39 in. (59.7 × 99.1 cm), image: 32½ × 44 in. (82.6 × 111.8 cm). California African American Museum, Los Angeles, Gift of Impressions Limited Atelier.

FAITH RINGGOLD
(b. 1930 New York, NY)

The artist and political activist Faith Ringgold was born in Harlem in 1930, toward the end of the Harlem Renaissance. She studied with the painter Robert Gwathmey at the City College of New York and taught art in the New York City public school system for eighteen years. In the late 1960s, she met many artists of the Harlem Renaissance, including Charles Alston, Romare Bearden, Jacob Lawrence, and Hale Woodruff. By the late 1970s, her works reflected and honored the lives of people associated with Harlem, combining three traditional African American forms: painting, quilting, and storytelling. The title of her story quilt *Groovin High* (1986; Spelman College Museum of Fine Art, Atlanta), as well as the screenprint of the same composition (1986; cat. 48), refers to the 1945 bebop standard by the jazz composer and trumpeter Dizzy Gillespie. Spirited dancers overlap one another, creating a vibrant, dynamic composition that evokes the energy of clubs and dance halls that thrived during the Harlem Renaissance.

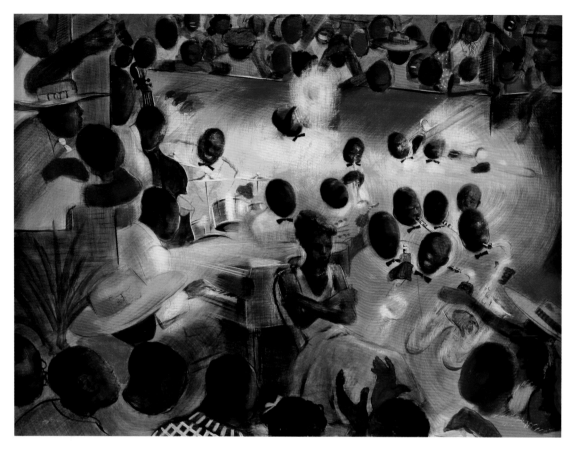

Cat. 49 Jay Robinson (b. 1915), *Count Basie and Billie Holiday at the Graystone Ballroom, Detroit*, ca. 1947. Egg tempera on gesso panel, 26 × 36 in. (66 × 91.4 cm). Private collection.

JAY ROBINSON
(b. 1915 Detroit, MI)

Jay Robinson spent much of his youth in Kentucky and currently lives in Virginia. He earned his bachelor's degree from Yale University in 1937 and studied at the Cranbrook Academy of Art. Robinson served as a US Navy Training Aids Officer during World War II.

In 1948, Robinson had his first solo exhibition, at the Milch Galleries, in New York. The reviewer for the *New York Times* (December 4, 1948) wrote: "In the jazz themes, Robinson imposes a taut, excited line on splashing areas of bright color. He suggests the clanking noise of cymbals, the penetrating whine of the wind instruments and the beat of

the drums with extraordinary vividness." In *Billie Holiday Singing the Blues* (1947; cat. 18), Robinson depicted Lady Day and her audience enveloped in cerulean blue—a painterly equivalent of the music that would have suffused the show venue. In *Jump Band (Pete Brown on Alto Sax)* (1947; cat. 17), the gestural forms of the musicians evoke the atmosphere of the hazy smoke-filled clubs of the Jazz Age.

In 1950, Robinson received a fellowship from the Louis Comfort Tiffany Foundation to travel to the Belgian Congo (today the Democratic Republic of the Congo). He experimented with a wide range of artistic media throughout his career.

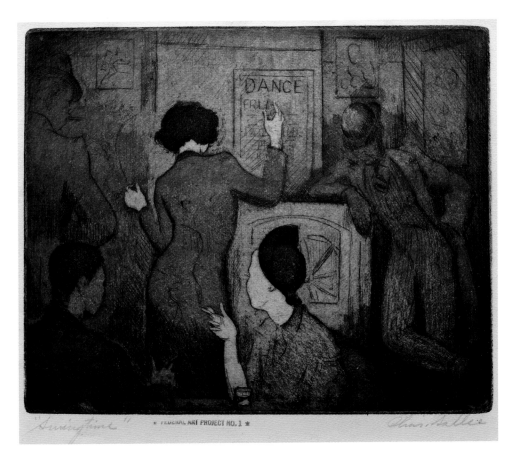

Cat. 50 Charles Sallee (1911–2006), *Swingtime*, 1937. Aquatint, etching on wove paper, sheet: 5½ × 6¹⁵⁄₁₆ in. (14 × 17.6 cm). Howard University Gallery of Art, Washington, DC.

Charles Sallee
(Oberlin, OH 1911–2006 Cleveland, OH)

Although Charles Sallee was born and worked in Ohio, his legacy links him to the Harlem Renaissance artists of the 1920s and 1930s. Sallee enrolled in art classes at Karamu House, a settlement that served Cleveland's poorest neighborhood and became a magnet for some of the most talented African American artists in the region. In 1934, he became the first African American to attend the Cleveland School of Art (now the Cleveland Institute of Art). In 1939, he earned a bachelor's degree in art education from Western Reserve University (now Case Western Reserve University). From 1935 to 1941, Sallee also worked for the

Works Progress Administration, painting murals and making prints. During World War II, he served in the military as a cartographer with the US Army Corp of Engineers and traveled to England, France, and the South Pacific.

Sallee was also one of Cleveland's leading interior designers, enjoying a large number of design commissions in the city, including the ballroom of the Hotel Cleveland. His first major design commission was the conversion of a restaurant into a nightclub—the Tijuana—that opened with a performance by Nat King Cole and attracted a number of well-known jazz and blues singers. Attesting to Sallee's interest in the music scene, his etching *Swingtime* (1937; cat. 50) offers a glimpse into Cleveland's nightlife.

Cat. 51 Aaron Siskind (1903–1991), *Apollo Theatre*, ca. 1937.
Gelatin silver print, 14 × 11 in. (35.6 × 27.9 cm).
A Gallery for Fine Photography, New Orleans.

AARON SISKIND
(New York, NY 1903–1991 Providence, RI)

Aaron Siskind, the son of Russian Jewish immigrants, attended the College of the City of New York (now the City College of New York). In 1926, he taught in the New York public school system. Siskind received his first camera in 1930 and began photographing New York's skyscrapers and streets. In 1932, he purchased a professional camera and joined the Film and Photo League, a group of amateur and professional photographers and filmmakers devoted to social documentation and change. In 1936, Siskind became the director of the Photo League's Feature Group, which produced photo-essays about urban working-class life. Siskind's photographs *Harlem Night Club* (ca. 1937; cat. 26) and *Apollo Theatre* (ca. 1937; cat. 51) were both part of the Feature Group's *Harlem Document* project (1932–40).

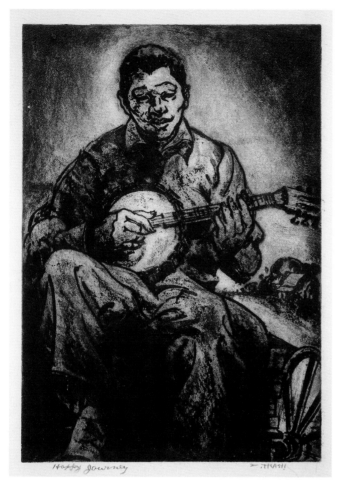

Cat. 52 Dox Thrash (1893–1965), *Happy Journey*, ca. 1939.
Relief etching, sheet: 11³/₁₆ × 8⅛ in. (28.4 × 20.6 cm),
image: 9¹⁵/₁₆ × 7 in. (25.2 × 17.8 cm). Philadelphia
Museum of Art, Gift of E. M. Benson.

DOX THRASH
(Griffin, GA 1893–1965 Beverly, NJ)

Dox Thrash grew up in a former slave cabin on the out-
skirts of Griffin, Georgia. He studied art in the rural South
but found limited opportunities. In 1911, Thrash moved to
Chicago and in 1914 enrolled at the School of the Art Insti-
tute of Chicago. In 1917, he joined the army and served in
the 365th Infantry Regiment, 183rd Brigade, 92nd Division,
an all-black unit famously known as the Buffalo Soldiers.
Thrash settled in Philadelphia in 1925 and lived there for
the rest of his life.

In 1930, Thrash was commissioned to design the poster
for the Second Annual National Negro Music Festival, at
the Academy of Music in Philadelphia. In 1937, he was
employed by the Works Progress Administration's Fine
Print Workshop, where he developed one of the most
innovative printmaking techniques of the twentieth cen-
tury, known as carborundum mezzotint. His prints often
reflected aspects of his rural southern heritage. Thrash's
carborundum relief etching *Happy Journey* (1940; cat. 52),
depicting a seated musician in a moment of solitude,
demonstrates the artist's deftness in balancing light and
dark passages to emphasize the subject's mood.

Cat. 53 James Van Der Zee (1886–1983), *Hazel Scott*, 1936.
Gelatin silver print, 9¹⁵⁄₁₆ × 8 in. (25.2 × 20.3 cm).
National Portrait Gallery, Smithsonian Institution,
Washington, DC.

JAMES VAN DER ZEE
(Lenox, MA 1886–1983 Washington, DC)

Regarded as one of the foremost photographers of the Harlem Renaissance, James Van Der Zee moved to Harlem intent on a career in music. Trained as a violinist and pianist, Van Der Zee pursued the more lucrative art of photography, becoming a darkroom technician at a department store. In 1916, he opened Guarantee Photography Studio, on West 135th Street, in the center of Harlem.

During the 1920s and 1930s, Van Der Zee produced studio portraits and photographed funerals, the political leader Marcus Garvey, and scenes of Harlem. Many leaders in the cultural renaissance posed for him, including the jazz singer Hazel Scott (1936; cat. 53).

Cat. 54 Carl Van Vechten (1880–1964), *Dizzy Gillespie*, 1955,
printed 1983. Photogravure, 8⅞ × 5⅞ in. (22.5 ×
14.9 cm). National Portrait Gallery, Smithsonian
Institution, Washington, DC.

CARL VAN VECHTEN
(Cedar Rapids, IA 1880–1964 New York, NY)

In 1906, the writer and photographer Carl Van Vechten
moved to New York City, where he soon became one of the
most influential figures of the Harlem Renaissance. Van
Vechten was hired as the assistant music critic for the *New
York Times*, and in 1913 he became the drama and theater
critic for the *New York Press*, for which he also reviewed
modern dance. Van Vechten's journalistic work introduced
him to some of the most celebrated musicians, writers, and
theater producers of the period.

In 1910, Van Vechten began his career as an author,
publishing essays on music, and in 1922 he published his
first novel, *Peter Whiffle: His Life and Works.* In 1924, he
was asked to review a manuscript by Walter White, the
assistant secretary for the National Association for the
Advancement of Colored People. Through his connection
to White, Van Vechten met the writer and activist James
Weldon Johnson, who introduced Van Vechten to some
of the most influential African Americans in Harlem. Van

Vechten—who was white—was eager to immerse him-
self in the African American community and to champion
the efforts of black artists and writers. He became an avid
collector of art and books pertaining to black culture in
Harlem. He helped publish many of Langston Hughes's
writings, including Hughes's first poetry collection, *The
Weary Blues* (1926). Van Vechten's novel about Harlem,
Nigger Heaven (1926), became one of the most controversial
publications in African American history.

Van Vechten worked as a news photographer for the
Chicago American (today the *Examiner*) in 1903 but took up
photography seriously in 1932. As a photographer, he set out
to capture an image of every significant African American
artist, writer, dancer, and political leader in Harlem. Van
Vechten's passion for Harlem, combined with his photo-
graphic interests, resulted in a remarkable chronicle of the
Harlem Renaissance. By his death in 1964, Van Vechten
had taken more than fifteen thousand pictures, including
portraits of Cab Calloway (1933; cat. 2), Countee Cullen
(1941; cat. 28), Dizzy Gillespie (1955; cat. 54), Langston
Hughes (1939; cat. 9), and Alain Locke (1941; cat. 25).

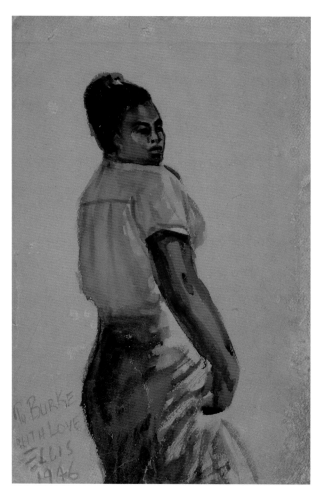

Cat. 55 Ellis Wilson (1899–1977), *Sassie Selma*, 1946.
Watercolor and graphite, 16 × 11 in. (40.6 × 27.9 cm).
Amistad Research Center, Tulane University,
New Orleans.

ELLIS WILSON
(Mayfield, KY 1899–1977 New York, NY)

Ellis Wilson studied agriculture and education (the only options for an African American man) at Kentucky Normal and Industrial Institute (now part of Kentucky State University), in Frankfort, and was later a student at the School of the Art Institute of Chicago. After Wilson graduated with honors in 1923, he remained in Chicago for five years, working as a commercial artist. In 1928, he moved to New York, where he became involved in the Harlem Artists Guild. In 1929, a design by Wilson was used on the cover of *The Crisis* magazine, and in 1930 he exhibited with the Harmon Foundation. Wilson also worked as a mural painter with the Federal Art Project during this time.

Wilson's paintings from the 1930s capture many aspects of the lives of African Americans in Harlem. *Shore Leave* (1943; cat. 3) depicts a gathering of World War II servicemen and dancers, rhythmically swaying. Although Wilson found culturally vibrant New York to be an ideal place to live and paint, he turned to portrayals of the South in his later work. In 1944, he received a Guggenheim Fellowship to travel to Georgia, Tennessee, South Carolina, and Kentucky, painting African American life in these areas.

Hale Woodruff (1900–1980), *By Parties Unknown*, 1935, printed 1996. From the portfolio *Selections from the Atlanta Period*. Linocut, sheet: 19 × 15 in. (48.3 × 38.1 cm), image: 12⅛ × 8⅞ in. (30.8 × 22.5 cm). Gibbes Museum of Art, Charleston, SC, Gift of Reba and Dave Williams.

HALE WOODRUFF
(Cairo, IL 1900–1980 New York, NY)

Hale Woodruff began his career as a landscape artist in Indianapolis. He studied landscape painting at the John Herron Institute of Art (now the Herron School of Art and Design) with the noted American Impressionist William J. Forsyth.

In 1925, an illustration by Woodruff appeared on the cover of *The Crisis* magazine, and the following year he won the bronze award in fine arts from the Harmon Foundation. In 1927, he traveled to France, where he studied with Henry Ossawa Tanner, who was the first African American artist to gain international acclaim. Working abroad, Woodruff experienced more opportunities than in the United States. While in France, he collected African masks and studied the paintings of Henri Matisse and Paul Cézanne, whose influence is evident in his modernist work *Card Players* (1930; cat. 20). Composed of flat planes, and with modernist compositional elements and motifs such as African-masked faces, *Card Players* pays homage to a traditional theme in French painting. In 1931, Woodruff returned to the United States and joined the art department at Atlanta University, where he taught for more than a decade.

Exhibition Checklist

CHARLES ALSTON (1907–1977)

Lindy Hop at the Savoy, ca. late 1930s. Watercolor. 13 × 9 in. (33 × 22.9 cm). Thelma Harris Gallery, Oakland, CA.

Stud Poker, 1935. Lithograph. Sheet: 15⅜ × 19³⁄₁₆ in. (39 × 48.7 cm), image: 12¾ × 16⅛ in. (32.4 × 41 cm). Metropolitan Museum of Art, New York, Gift of New York City WPA, 1943.

RICHMOND BARTHÉ (1901–1989)

Head of a Dancer, 1937. Bronze. 18 × 7 × 6 in. (45.7 × 17.8 × 15.2 cm). SCAD Museum of Art, Savannah, Gift of Dr. Walter O. Evans and Mrs. Linda J. Evans.

Head of Jimmy Daniels, ca. 1933. Bronze. 11½ × 6 × 8 in. (29.2 × 15.2 × 20.3 cm). Gibbes Museum of Art, Charleston, SC, Gift of Alan L. Wolfe.

ROMARE BEARDEN (1911–1988)

Jazz II, 1980. Screenprint. Sheet: 31 × 41½ in. (78.7 × 105.4 cm), image: 26⅞ × 37¹¹⁄₁₆ in. (68.3 × 95.8 cm). Stella Jones Gallery, New Orleans.

Jazz Rhapsody, 1982. Collage on board. 8½ × 11 in. (21.6 × 27.9 cm). SCAD Museum of Art, Savannah, Gift of Dr. Walter O. Evans and Mrs. Linda J. Evans.

Louisiana Serenade, 1979. Lithograph. Sheet/image: 24½ × 33⅞ in. (62.2 × 86.2 cm). Smithsonian American Art Museum, Washington, DC, Gift of Eugene I. Schuster.

Piano Lesson, 1986. Screenprint. Sheet: 37 × 28¼ in. (94 × 71.8 cm), image: 29¼ × 20¼ in. (74.3 × 51.4 cm). California African American Museum, Los Angeles, Bequest of Alfred C. Darby.

Serenade, 1969. Collage and paint on panel. 45¾ × 32½ in. (116.2 × 82.6 cm). Madison Museum of Contemporary Art, WI, purchase through National Endowment for the Arts grant with matching funds from Madison Art Center members.

Twin Quartet, 1981. Oil and collage on canvas. 30 × 36 in. (76.2 × 91.4 cm). Collection of Jumaane N'Namdi.

GWENDOLYN BENNETT (1902–1981)

Adam & Eve, 1932. Ink on paper. 18 × 13 in. (45.7 × 33 cm). Amistad Research Center, Tulane University, New Orleans.

CLAUDE CLARK (1915–2001)

Jam Session, 1943. Oil on canvas. 20 × 18 in. (50.8 × 45.7 cm). Philadelphia Museum of Art, Purchased with the Julius Bloch Memorial Fund created by Benjamin D. Bernstein, 1998.

ALLAN ROHAN CRITE (1910–2007)
Douglass Square, 1936. Oil on canvas-covered artist's board. 23½ × 27 in. (59.7 × 68.6 cm). Saint Louis Art Museum, MO, Gift of the Federal Works Agency, Work Projects Administration.

CHARLES CULLEN (1889–1963)
Illustration for "Color" (Tableau with Sunrays), 1925. Ink on paper. 26 × 35 in. (66 × 88.9 cm). Amistad Research Center, Tulane University, New Orleans.

AARON DOUGLAS (1899–1979)
The Judgment Day, 1927. Gouache on paper. 11¾ × 9 in. (29.8 × 22.9 cm). SCAD Museum of Art, Savannah, Gift of Dr. Walter O. Evans and Mrs. Linda J. Evans.

Play de Blues, 1926. From the *"Opportunity" Art Folio*. Relief print, letterpress on paper. Sheet: 16 × 11½ in. (40.6 × 29.2 cm). Spencer Museum of Art, University of Kansas, Lawrence, Helen Foresman Spencer Art Acquisition Fund, Lucy Shaw Schultz Fund, and Office of the Chancellor.

Rise, Shine for Thy Light Has Come, 1924. Ink and tempera on paper. 11⅓ × 8¼ in. (28.8 × 21 cm). Howard University Gallery of Art, Washington, DC.

Sahdji (Tribal Women), 1925. Ink and graphite on wove paper. 12¹/₁₆ × 9 in. (30.6 × 22.9 cm). Howard University Gallery of Art, Washington, DC.

JOHN GUTMANN (1905–1998)
Untitled, 1936. Gelatin silver print. 7½ × 7¹⁵/₁₆ in. (19 × 20.2 cm). Center for Creative Photography, University of Arizona, Tuscon.

MALVIN GRAY JOHNSON (1896–1934)
Elks Marching, 1934. Oil on canvas. 16 × 19 in. (40.6 × 48.3 cm). Amistad Research Center, Tulane University, New Orleans.

SARGENT CLAUDE JOHNSON (1888–1967)
Singing Saints, 1940. Lithograph. Sheet: 26½ × 19½ in. (67.3 × 49.5 cm), image: 12 × 9¼ in. (30.5 × 23.5 cm). California African American Museum, Los Angeles.

WILLIAM HENRY JOHNSON (1901–1970)
Folk Family, 1942. Screenprint with pencil. Sheet/image: 18 × 13⅞ in. (45.8 × 35.3 cm). Amistad Research Center, Tulane University, New Orleans.

Jitterbugs II, 1942. Screenprint. Sheet/image: 14 × 11 in. (35.6 × 27.9 cm). Amistad Research Center, Tulane University, New Orleans.

Sowing, ca. 1942. Screenprint. Sheet/image: 11½ × 16 in. (29.2 × 40.6 cm). Gibbes Museum of Art, Charleston, SC, Museum Purchase with funds provided by the Anna Heyward Taylor Fund.

Loïs Mailou Jones (1905–1998)

Rue Saint Michel, 1938. Oil on canvas. 28 × 23 in. (71.1 × 58.4 cm). Amistad Research Center, Tulane University, New Orleans.

A Student at Howard, 1947. Watercolor over graphite. 20 × 14 in. (50.8 × 35.6 cm). Bowdoin College Museum of Art, Brunswick, ME, Gift of Eliot O'Hara.

Jacob Lawrence (1917–2000)

The Brown Angel, 1959. Tempera on gesso panel. 23⁵/₁₆ × 19¼ in. (59.2 × 48.9 cm). Museum of Fine Arts, Houston, TX, Gift of the Caroline Wiess Law Foundation, with additional funds provided by the African American Art Advisory Association and ExxonMobil.

Self Portrait, ca. 1965. Ink and gouache over charcoal. 19 × 12¹/₁₆ in. (48.3 × 30.6 cm). National Portrait Gallery, Smithsonian Institution, Washington, DC.

Archibald J. Motley Jr. (1891–1981)

Jazz Singers, ca. 1934. Oil on canvas. 32 × 42 in. (81.3 × 106.7 cm). Western Illinois University Art Gallery, Macomb, Courtesy of the Fine Arts Program, Public Buildings Service, US General Services Administration, Commissioned through the New Deal art projects.

Richard Bruce Nugent (1906–1987)

Three Plates with Designs of Dancing Figures, 1952. Ceramic. Diam. 9 in. (22.9 cm) each. Amistad Research Center, Tulane University, New Orleans.

Marion Palfi (1907–1978)

New York, Social Work, ca. 1946. Gelatin silver print. 9⁵/₈ × 7¾ in. (24.4 × 19.7 cm). Center for Creative Photography, University of Arizona, Tucson.

Prentice Herman Polk (1898–1984)

Catherine Moton Patterson (Woman Playing the Harp in an Evening Gown), 1936. Gelatin silver print. 14 × 11 in. (35.6 × 27.9 cm). California African American Museum, Los Angeles, Gift of P. H. Polk.

Noble Sissle, 1937. Gelatin silver print. 10 × 8 in. (25.4 × 20.3 cm). California African American Museum, Los Angeles, Gift of P. H. Polk.

William Christopher Handy, 1942. Gelatin silver print. 9½ × 7½ in. (24.1 × 19 cm). National Portrait Gallery, Smithsonian Institution, Washington, DC.

Faith Ringgold (b. 1930)

Groovin High, 1986. Screenprint. Sheet: 23½ × 39 in. (59.7 × 99.1 cm), image: 32½ × 44 in. (82.6 × 111.8 cm). California African American Museum, Los Angeles, Gift of Impressions Limited Atelier.

Jay Robinson (b. 1915)

Count Basie and Billie Holiday at the Graystone Ballroom, Detroit, ca. 1947. Egg tempera on gesso panel. 26 × 36 in. (66 × 91.4 cm). Private collection.

Billie Holiday Singing the Blues, 1947. Oil on canvas. 20½ × 16 in. (52.1 × 40.6 cm). Georgia Museum of Art, University of Georgia, Athens, Gift of Mr. and Mrs. Jason Schoen in honor of William Underwood Eiland.

Jump Band (Pete Brown on Alto Sax), 1947. Oil on canvas. 34 × 40 in. (86.4 × 101.6 cm). Private collection.

Charles Sallee (1911–2006)

Swingtime, 1937. Aquatint, etching on wove paper. Sheet: 5½ × 6¹⁵/₁₆ in. (14 × 17.6 cm). Howard University Gallery of Art, Washington, DC.

Aaron Siskind (1903–1991)

Apollo Theatre, ca. 1937. Gelatin silver print. 14 × 11 in. (35.6 × 27.9 cm). A Gallery for Fine Photography, New Orleans.

Harlem Night Club, ca. 1937. Gelatin silver print. 14 × 11 in. (35.6 × 27.9 cm). A Gallery for Fine Photography, New Orleans.

Dox Thrash (1893–1965)

Happy Journey, ca. 1939. Relief etching. Sheet: 11³/₁₆ × 8⅛ in. (28.4 × 20.6 cm), image: 9¹⁵/₁₆ × 7 in. (25.2 × 17.8 cm). Mary and Leigh Block Museum of Art, Northwestern University, Evanston, IL.

James Van Der Zee (1886–1983)

Dance Class, 1928. Gelatin silver print. 8¹/₁₆ × 10 in. (20.5 × 25.4 cm). Spencer Museum of Art, University of Kansas, Lawrence, Museum purchase: Peter T. Bohan Art Acquisition Fund.

Hazel Scott, 1936. Gelatin silver print. 9¹⁵/₁₆ × 8 in. (25.2 × 20.3 cm). National Portrait Gallery, Smithsonian Institution, Washington, DC.

CARL VAN VECHTEN (1880–1964)
Alain Leroy Locke, 1941, printed 1983. Photogravure. Framed: 24 × 16 in. (22.4 × 15.1 cm). National Portrait Gallery, Smithsonian Institution, Washington, DC.

Cab Calloway, 1933. Gelatin silver print. 5³/₈ in. × 3⁷/₁₆ in. (13.7 × 8.7 cm). National Portrait Gallery, Smithsonian Institution, Washington, DC.

Countee Cullen, 1941, printed 1983. Photogravure. 8³/₄ × 5⁷/₈ in. (22.3 × 14.9 cm).. National Portrait Gallery, Smithsonian Institution, Washington, DC.

Dizzy Gillespie, 1955, printed 1983. Photogravure. 8⁷/₈ × 5⁷/₈ in. (22.5 × 14.9 cm). National Portrait Gallery, Smithsonian Institution, Washington, DC.

Langston Hughes, 1939, printed 1983. Photogravure. Framed: 16 × 24 in. (14.1 × 21.4 cm). National Portrait Gallery, Smithsonian Institution, Washington, DC, Gift of Prentiss Taylor.

ELLIS WILSON (1899–1977)
Sassie Selma, 1946. Watercolor and graphite. 16 × 11 in. (40.6 × 27.9 cm). Amistad Research Center, Tulane University, New Orleans.

Shore Leave, 1943. Oil on Masonite. 16 × 20 in. (40.6 × 50.8 cm). Amistad Research Center, Tulane University, New Orleans.

HALE WOODRUFF (1900–1980)
Blind Musician, 1935. Woodcut. Sheet: 19⁵/₁₆ × 15¹/₁₆ in. (49.1 × 38.3 cm), image: 6¹/₁₆ × 4¹/₁₆ in. (15.4 × 10.3 cm). Brooklyn Museum, NY, Gift of E. Thomas Williams Jr. and Auldlyn Higgins Williams.

By Parties Unknown, 1935, printed 1996. From the portfolio *Selections from the Atlanta Period*. Linocut. Sheet: 19 × 15 in. (48.3 × 38.1 cm), image: 12¹/₈ × 8⁷/₈ in. (30.8 × 22.5 cm). Gibbes Museum of Art, Charleston, SC, Gift of Reba and Dave Williams.

Card Players, 1930, repainted 1978. Oil on canvas. 36 × 42 in. (91.4 × 106.7 cm). Harvey B. Gantt Center for African-American Arts + Culture, Charlotte, NC.

Old Church, 1935, printed 1996. From the portfolio *Selections from the Atlanta Period*. Linocut. Sheet: 15 × 19 in. (38.1 × 48.3 cm), image: 6½ × 9 in. (16.5 × 22.9 cm). Gibbes Museum of Art, Charleston, SC, Gift of Reba and Dave Williams.

Relics, 1935, printed 1996. From the portfolio *Selections from the Atlanta Period*. Linocut. Sheet: 15 × 19 in. (38.1 × 48.3 cm), image: 8 × 11 in. (20.3 × 27.9 cm). Gibbes Museum of Art, Charleston, SC, Gift of Reba and Dave Williams.

Returning Home, 1935, printed 1996. From the portfolio *Selections from the Atlanta Period*. Linocut. Sheet: 19 × 15 in. (48.3 × 38.1 cm), image: 10 × 8 in. (25.4 × 20.3 cm). Gibbes Museum of Art, Charleston, SC, Gift of Reba and Dave Williams.

Sunday Promenade, ca. 1935, printed 1996. From the portfolio *Selections from the Atlanta Period*. Linocut. Sheet: 19 × 15 in. (48.3 × 38.1 cm), image: 9³/₄ × 7³/₄ in. (24.8 × 19.7 cm). Gibbes Museum of Art, Charleston, SC, Gift of Reba and Dave Williams.

Selected Bibliography

Primary Sources

Alfred A. Knopf, Inc. Records. Harry Ransom Center, University of Texas at Austin.

Alston, Charles Henry, Papers. Archives of American Art, Smithsonian Institution, Washington, DC.

——. Interview by Al Murray, October 19, 1968. Oral History Project, Archives of American Art, Smithsonian Institution, Washington, DC.

Barthé, Richmond, Papers. Amistad Research Center, Tulane University, New Orleans.

Bearden, Romare, Papers. Archives of American Art, Smithsonian Institution, Washington, DC.

——. Interview by Avis Burman, July 31, 1980. Oral History Project, Archives of American Art, Smithsonian Institution, Washington, DC.

Bennett, Gwendolyn, Papers. Amistad Research Center, Tulane University, New Orleans.

Bush-Banks, Olivia Ward, Papers. Amistad Research Center, Tulane University, New Orleans.

Cahill, Holger, Papers. Archives of American Art, Smithsonian Institution, Washington, DC.

Cullen, Countee, Papers. Amistad Research Center, Tulane University, New Orleans.

Cunard, Nancy, Papers. Harry Ransom Center, University of Texas at Austin.

Douglas, Aaron. Interview by L. M. Collins, July 16, 1971. Black Oral History, Fisk University Special Collections, Nashville.

——. Interview by Ann Allen Shockley, November 19, 1975. Black Oral History, Fisk University Special Collections, Nashville.

Downtown Gallery. Records. Archives of American Art, Smithsonian Institution, Washington, DC.

Harmon Foundation. Files. National Portrait Gallery, Smithsonian Institution, Washington, DC.

——. Manuscripts. Library of Congress, Washington, DC.

Hurst, Fannie, Papers. Harry Ransom Center, University of Texas at Austin.

Lawrence, Jacob, and Gwendolyn Knight, Papers. Archives of American Art, Smithsonian Institution, Washington, DC.

Motley, Archibald J., Jr. Interviews by Dennis Barrie, January 23, 1978–March 1, 1979. Oral History Project, Archives of American Art, Smithsonian Institution, Washington, DC.

Taylor, Prentiss, Papers. Archives of American Art, Smithsonian Institution, Washington, DC.

Van Vechten, Carl, Literary File. Photography Collection, Harry Ransom Center, University of Texas at Austin.

Woodruff, Hale, Papers. Amistad Research Center, Tulane University, New Orleans.

————. Interview by Al Murray, November 18, 1968. Oral History Project, Archives of American Art, Smithsonian Institution, Washington, DC.

SECONDARY SOURCES

Abbott, Lynn. *Ragged but Right: Black Traveling Shows, "Coon Songs," and the Dark Pathway to Blues and Jazz.* Jackson: University Press of Mississippi, 2007.

Amaki, Amalia K., ed. *A Century of African American Art: The Paul R. Jones Collection.* Newark: University Museum, University of Delaware; New Brunswick, NJ: Rutgers University Press, 2004.

————. *Hale Woodruff, Nancy Elizabeth Prophet, and the Academy.* Atlanta: Spelman College Museum of Fine Art, 2007.

Anderson, Paul Allen. *Deep River: Music and Memory in Harlem Renaissance Thought.* Durham, NC: Duke University Press, 2001.

Banks, William M. *Black Intellectuals: Race and Responsibility in American Life.* New York: W. W. Norton, 1996.

Bascom, Lionel C., ed. *A Renaissance in Harlem: Lost Essays of the WPA, by Ralph Ellison, Dorothy West, and Other Voices of a Generation.* New York: Amistad, 2001.

Black, Patti Carr. *American Masters of the Mississippi Gulf Coast: George Ohr, Dusti Bonge, Walter Anderson, Richmond Barthé.* Jackson: University Press of Mississippi, 2008.

Calo, Mary Ann. *Distinction and Denial: Race, Nation, and the Critical Construction of the African American Artist, 1920–40.* Ann Arbor: University of Michigan Press, 2007.

Carroll, Anne Elizabeth. *Word, Image, and the New Negro: Representation and Identity in the Harlem Renaissance.* Bloomington: Indiana University Press, 2005.

Cassidy, Donna. *Painting the Musical City: Jazz and Cultural Identity in American Art, 1910–1940.* Washington, DC: Smithsonian Institution Press, 1997.

Charles Alston: Artist and Teacher; May 13, 1990–July 1, 1990, Kenkeleba Gallery. New York: Kenkeleba House, 1990.

Codrescu, Andrei, and Terrence Pitts. *Reframing America: Alexander Alland, Otto Hagel & Hansel Mieth, John Gutmann, Lisette Model, Marion Palfi, Robert Frank.* Albuquerque: University of New Mexico Press, 1995.

Corbould, Clare. *Becoming African Americans: Black Public Life in Harlem, 1919–1939.* Cambridge, MA: Harvard University Press, 2009.

Driskell, David. *Harlem Renaissance: Art of Black America.* New York: The Studio Museum in Harlem and Harry N. Abrams, 1987.

Fabre, Michel. *From Harlem to Paris: Black American Writers in France, 1840–1980.* Urbana: University of Illinois Press, 1991.

Faith, Berry. "Black Poets, White Patrons: The Harlem Renaissance Years of Langston Hughes." *Crisis* 88, no. 6 (1981): 278–85.

Farrington, Lisa E. *Creating Their Own Image: The History of African-American Women Artists.* Oxford: Oxford University Press, 2005.

Ferguson, Blanche E. *Countee Cullen and the Negro Renaissance.* New York: Dodd, Mead, 1966.

Garber, Marjorie. *Patronizing the Arts.* Princeton, NJ: Princeton University Press, 2008.

Goeser, Caroline. *Picturing the New Negro: Harlem Renaissance Print Culture and Modern Black Identity.* Lawrence: University Press of Kansas, 2007.

Harris, Michael D. *Colored Pictures: Race and Visual Representation.* Chapel Hill: University of North Carolina Press, 2003.

Henkes, Robert. *The Art of Black American Women: Works of Twenty-Four Artists of the Twentieth Century.* Jefferson, NC: McFarland, 1993.

Kirschke, Amy Helene. *Aaron Douglas: Art, Race, and the Harlem Renaissance.* Jackson: University Press of Mississippi, 1995.

Krasner, David. *A Beautiful Pageant: African American Theatre, Drama, and Performance in the Harlem Renaissance, 1910–1927.* New York: Palgrave Macmillan, 2002.

Leininger-Miller, Theresa A. *New Negro Artists in Paris: African American Painters and Sculptors in the City of Light, 1922–1934.* New Brunswick, NJ: Rutgers University Press, 2001.

Lewis, David L. *When Harlem Was in Vogue.* New York: Knopf, 1981.

Nesbett, Peter T. *The Complete Jacob Lawrence.* Seattle: University of Washington Press in association with Jacob Lawrence Catalogue Raisonné Project, 2000.

Powell, Richard J. *The Blues Aesthetic: Black Culture and Modernism.* Washington, DC: Washington Project for the Arts, 1989.

———. *Homecoming: The Art and Life of William H. Johnson.* Washington, DC: National Museum of American Art, Smithsonian Institution; New York: Rizzoli, 1991.

Price, Sally. *Romare Bearden: The Caribbean Dimension.* Philadelphia: University of Pennsylvania Press, 2006.

Reynolds, Gary A. *Against the Odds: African-American Artists and the Harmon Foundation.* Newark, NJ: Newark Museum, 1989.

Rodgers, Kenneth G. *Climbing Up the Mountain: The Modern Art of Malvin Gray Johnson.* Durham: North Carolina Central University Art Museum, 2002.

Schneider, Mark R. *African Americans in the Jazz Age: A Decade of Struggle and Promise.* Lanham, MD: Rowman & Littlefield, 2006.

Schulman, Daniel. *A Force for Change: African American Art and the Julius Rosenwald Fund.* Chicago: Spertus Museum; [Evanston, IL]: Northwestern University Press, 2009.

Stewart, Jeffrey C. "Black Modernism and White Patronage." *International Review of African American Art* 11, no. 3 (1994): 43–55.

Story, Ralph D. "Patronage and the Harlem Renaissance: You Get What You Pay For." *College Language Association Journal* 32, no. 3 (March 1989): 284–95.

Turner, Steve. *William H. Johnson: Truth Be Told.* Los Angeles: Seven Arts Publishing, 1998.

Vendryes, Margaret Rose. "Art in the Archives: The Origins of the Art Representing the Core of the Aaron Douglas Collection from the Amistad Research Center." MA thesis, Tulane University, 1992.

———. *Barthé: A Life in Sculpture.* Jackson: University Press of Mississippi, 2008.

West, Aberjhani, and Sandra L. West. *Encyclopedia of the Harlem Renaissance.* New York: Facts on File, 2003.

Wheat, Ellen Harkins. *Jacob Lawrence, American Painter.* Seattle: University of Washington Press in association with the Seattle Art Museum, 1986.

Wintz, Cary D. *Harlem Speaks: A Living History of the Harlem Renaissance.* Naperville, IL: Sourcebooks, 2007.

Wintz, Cary D., and Paul Finkelman, eds. *Encyclopedia of the Harlem Renaissance.* New York: Taylor and Francis, 2012.

Illustration Credits

Every effort has been made to contact the owners and photographers of objects reproduced here whose names do not appear in the captions or in the illustration credits listed below. Anyone having further information concerning copyright holders is asked to contact the LSU Museum of Art so that this information can be included in future printings.

© The Estate of Charles Alston: p. 12 [Charles Alston, *Lindy Hop at the Savoy*]

Art Resource, NY: cats. 2, 9, 21, 24, 25, 28, 30, 53, 54 [Carl Van Vechten, *Cab Calloway*; Van Vechten, *Langston Hughes*; Prentis Herman Polk, *William Christopher Handy*; Jacob Lawrence, *Self-Portrait*; Van Vechten, *Alain Leroy Locke*; Van Vechten, *Countee Cullen*; Charles Alston, *Stud Poker*; James Van Der Zee, *Hazel Scott*; Van Vechten, *Dizzy Gillespie*]

© Romare Bearden Foundation / Licensed by VAGA, New York, NY: p. 4; cats. 5, 7, 8, 29, 32 [Romare Bearden, *Serenade*; Bearden, *Jazz II*; Bearden, *Louisiana Serenade*; Bearden, *Jazz Rhapsody*; Bearden, *Piano Lesson* (Photo: Gene Ogami); Bearden, *Twin Quartet*]

© 1998 Center for Creative Photography, Arizona Board of Regents: cats. 38, 46 [John Gutmann, *Untitled*; Marion Palfi, *New York, Social Work*]

© Heirs of Aaron Douglas / Licensed by VAGA, New York, NY: cats. 10, 13, 23, 37 [Aaron Douglas, *Rise, Shine for Thy Light Has Come* (Photo: Greg Staley); Douglas, *Play de Blues*; Douglas, *Sahdji (Tribal Women)*; Douglas, *The Judgment Day*]

Gibbes Museum of Art / Carolina Art Association: cats. 4, 12, 15, 19, 31, 41, 56 [Hale Woodruff, *Sunday Promenade*; Woodruff, *Old Church*; Woodruff, *Returning Home*; Woodruff, *Relics*; Richmond Barthé, *Head of Jimmy Daniels*; William H. Johnson, *Sowing*; Woodruff, *By Parties Unknown*]

© 2013 The Jacob and Gwendolyn Lawrence Foundation, Seattle / Artists Rights Society (ARS), New York: cats. 24, 43 [Jacob Lawrence, *Self Portrait*; Lawrence, *The Brown Angel*]

© Courtesy of the Literary Representative for the Works of Gwendolyn Bennett, Schomburg Center for Research in Black Culture, The New York Public Library, Astor, Lenox and Tilden Foundations: cat. 33 [Gwendolyn Bennett, *Adam & Eve*]

© Loïs Mailou Jones Pierre-Noël Trust: cats. 27, 42 [Loïs Mailou Jones, *Rue Saint Michel*; Jones, *A Student at Howard*]

© Estate of P. H. Polk: cats. 11, 21, 47 [Prentice Herman Polk, *Noble Sissle*; Polk, *William Christopher Handy*; Polk, *Catherine Moton Patterson (Woman Playing the Harp in an Evening Gown)*]

© Faith Ringgold: cat. 48 [Faith Ringgold, *Groovin High*]

© 2013 Estate of Aaron Siskind: cats. 26, 51 [Aaron Siskind, *Harlem Night Club*; Siskind, *Apollo Theatre*]

Photo: Greg Staley: cat. 50 [Charles Sallee, *Swingtime*]

© Donna Van Der Zee: cats. 1, 53 [James Van Der Zee, *Dance Class*; Van Der Zee, *Hazel Scott*]

© Estate of Carl Van Vechten / Bruce Kellner, Successor Trustee: cats. 2, 9, 25, 28, 54 [Carl Van Vechten, *Cab Calloway*; Van Vechten, *Langston Hughes*; Van Vechten, *Alain Leroy Locke*; Van Vechten, *Countee Cullen*; Van Vechten, *Dizzy Gillespie*]

© 2013, Thomas H. Wirth: cat. 45 [Richard Bruce Nugent, *Three plates*]

© Estate of Hale Woodruff / Licensed by VAGA, New York, NY: cats. 4, 12, 15, 16, 19, 20, 56 [Hale Woodruff, *Sunday Promenade*; Woodruff, *Old Church*; Woodruff, *Returning Home*; Woodruff, *Blind Musician*; Woodruff, *Relics*; Woodruff, *Card Players*; Woodruff, *By Parties Unknown*]

This book is published in conjunction with the exhibition *The Visual Blues*, presented at the LSU Museum of Art, Baton Rouge, from March 8 to July 13, 2014, and at the Telfair Museums, Savannah, from January 30 to May 3, 2015.

Generous support for this exhibition has been provided by the National Endowment for the Arts, Washington, DC; the Louisiana State Arts Council through the Louisiana Division of the Arts and the National Endowment for the Arts as administered by the Arts Council of Greater Baton Rouge; the Louisiana Department of Culture, Recreation & Tourism; and the inaugural Art Dealers Association of America Foundation Curatorial Award administered by the Association of Art Museum Curators.

ART WORKS. | **National Endowment for the Arts** arts.gov

LOUISIANA OFFICE OF CULTURAL DEVELOPMENT — DIVISION OF THE ARTS — DEVELOPING OUR CULTURAL ASSETS

arts COUNCIL OF GREATER BATON ROUGE

LOU!S!ANA *Pick your Passion* LouisianaTravel.com

LSU | **Museum of Art**
AT THE SHAW CENTER FOR THE ARTS

LCCN: 2013949519
ISBN: 9780615878300

Published by LSU Museum of Art, Baton Rouge
www.lsumoa.org

Distributed by the University of Washington Press, Seattle
www.washington.edu/uwpress

Produced by Marquand Books, Inc., Seattle
www.marquandbooks.com

Designed by Ryan Polich
Proofread by Laura Iwasaki
Typeset in Cala and Tungsten by Brielyn Flones
Color management by iocolor, Seattle
Printed and bound in China by C&C Offset Printing Co., Ltd.

Front cover: William Henry Johnson (1901–1970), *Jitterbugs II* (detail of cat. 6), 1942

Back cover: Aaron Siskind (1903–1991), *Apollo Theatre* (detail of cat. 51), ca. 1937

Frontispiece: Claude Clark (1915–2001), *Jam Session* (detail of cat. 34), 1943

Page 4: Romare Bearden (1911–1988), *Serenade* (detail), 1969

Pages 6–7: Jay Robinson (b. 1915), *Count Basie and Billie Holiday at the Graystone Ballroom, Detroit* (detail of cat. 49), ca. 1947